LOVER

Portraits by 40 great artists

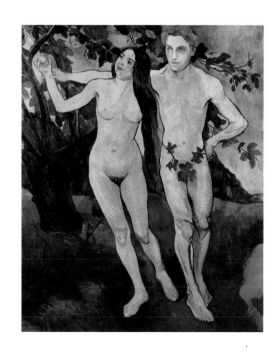

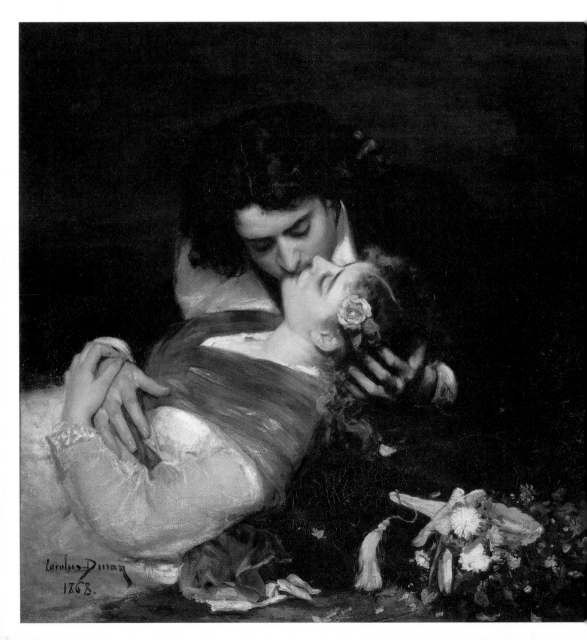

LOVER

Portraits by 40 great artists

JULIET HESLEWOOD

FRANCES LINCOLN LIMITED
PUBLISHERS

CONTENTS

Front cover: GUSTAV KLIMT *Emilie Flöge* 1902

Back cover: GEORGES SEURAT
Young Woman Powdering Herself 1890

Half title page: SUZANNE VALADON
Adam and Eve 1909

Title page: CHARLES AUGUSTE EMILE DURAN
(CAROLUS-DURAN) *The Kiss* 1868

Below: SANDRO BOTTICELLI
The Birth of Venus c.1485
Tempera on canvas, 172.5 x 278.5 cm
Galleria degli Uffizi, Florence

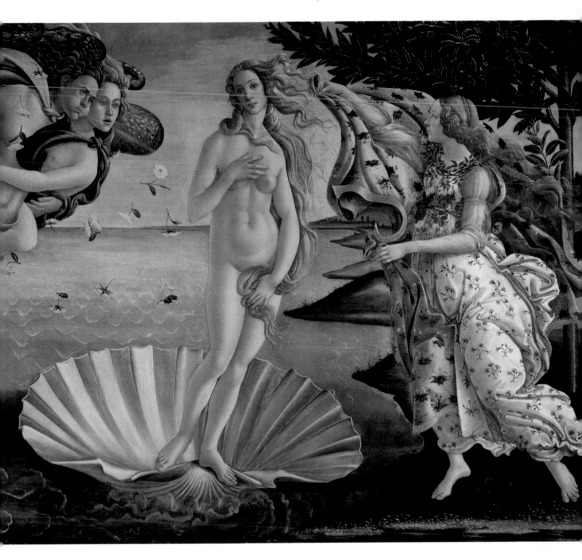

INTRODUCTION

Love – the theme can be found in great works of literature, music and the fine arts throughout many centuries. Love shared between human beings has been described by artists in myriad ways. Love is a universal subject, of never-ending interest since it touches every one of us. Less well known are the personal intimacies experienced by artists themselves.

How did artists describe their own feelings of love? Who are these lovers and what are their ideas concerning this exalted state? Taking a closer look at their individual stories, it becomes clear that love is valued in different ways. Love does not always run smoothly. Love can be painful, even destructive. Lovers have, at times, felt the need to hide their love, if it was considered socially unacceptable.

Love can also be a force that seems to make the world go round. Many artists illustrate their affection by portraying their loved ones. Love may be joyful and forward looking, with lovers willing to unite. The artists' vision explores this positive feeling and may, at the same time, show a stylistic preoccupation which is being pursued. Fernand Léger met his delightful girlfriend, Jeanne, just before the First World War. She is said to have dressed as a soldier in order to make love to him in the trenches. She figures in several of Léger's early works where his interest in Cubism transforms

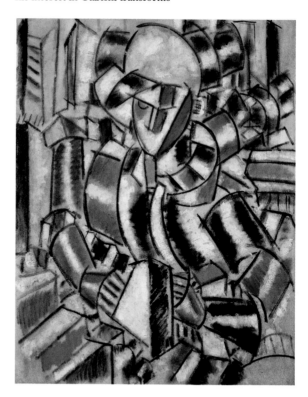

FERNAND LEGER
Woman in Red and Green 1914
Oil on canvas, 100 x 81 cm
Musée National d'Art Moderne,
Centre Pompidou, Paris

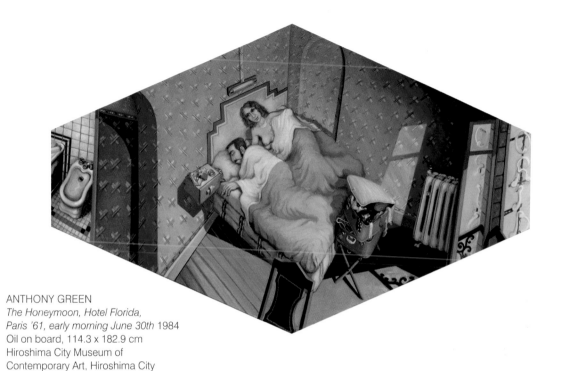

ANTHONY GREEN
The Honeymoon, Hotel Florida,
Paris '61, early morning June 30th 1984
Oil on board, 114.3 x 182.9 cm
Hiroshima City Museum of
Contemporary Art, Hiroshima City

her into a fragmented rather than pretty image. After the war these lovers were married.

The lover may become the spouse but remains the same person, despite the change in social status that marriage brings. Many portraits of wives, for example, show the continuing affection felt for them by their loving suitors. Constable painted Maria Bicknell as a childhood friend and again, years later, when they were newly married. The wedding itself is often the subject of artworks that go beyond the formality of official photography. Anthony Green painted a scene of his honeymoon, inviting us into the privacy of the hotel room he shared with his new wife, where every object is reproduced with the clarity of intensely felt memory.

If the lover or spouse shares the artist's life, they are likely to become sitters. The Pre-Raphaelites used each other as models to obtain a truth to natural appearances.

Through their art their mistresses and wives became enigmatic, even otherworldly characters. Edward Burne-Jones' passionate, adulterous affair with Maria Zambaco provided him with a woman who was the embodiment of a dark, brooding female, well suited to his mythological or allegorical subjects.

The Impressionists painted aspects of their own everyday lives, raising the theme of contemporary social activity to one suitable for serious art. Their families, friends and lovers are present in their domestic environments of picnics, café rendezvous and in the half-lit intimacy of dishevelled bedrooms.

Professional, paid models had a definite role in the past but their social position was frequently met with disapproval because of the nature of their work. Posing for artists (often in the nude) was thought likely to lead to scandalous liaisons. The lovely red-headed model, Joanna Hiffernan, posed for James McNeill Whistler and Gustave Courbet and was romantically linked to both men. Not always named in titles, she appears in Courbet's *La Belle Irlandaise* and as a figure in white in Whistler's numbered symphonies. Some critics fantasized about her identity in this painting seeing her

EDWARD BURNE-JONES
Portrait of Maria Zambaco 1870
Gouache, 76.3 x 55 cm
Clemens-Sels-Museum, Neuss

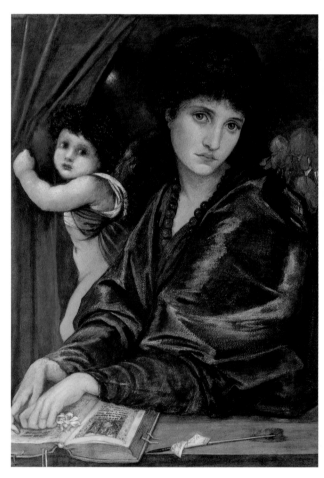

JAMES McNEILL WHISTLER
Symphony in White, No.1:
The White Girl 1862
Oil on canvas, 213 x 107.9 cm
National Gallery of Art, Washington,
Harris Whittemore Collection

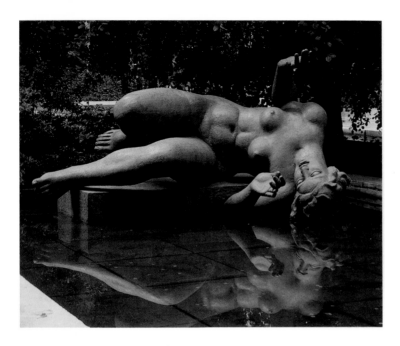

ARISTIDE MAILLOL
The River 1938–39
Lead on lead base,
136.5 x 228.6 x 167.7 cm
Museum of Modern Art, New York

as a new bride recalling her lost virginity, as a fallen woman, as a sleepwalker and even as a spirit.

Can such a lover, making frequent appearances in an artist's work, be thought of as a muse? Is the role of muse elevated, more spiritually inspiring than that of the worldly model? Does a muse have to be a lover or is it perhaps better if she is not? At the age of fifteen Dina Vierny met the sculptor Aristide Maillol who was sixty years older than herself. With rejuvenated energy at the end of his career he portrayed her majestic, full and firm body. During the Second World War, with Maillol's help, she was rescued from the Gestapo. Today she is best known in several versions of Maillol's statue *The River* and as a muse rather than a lover she remains exemplary. Both Henri Matisse and Pierre Bonnard, as well as Maillol, claimed that their creativity was renewed because she posed for them.

Lover or spouse, model or muse, they frequently take up their poses for the artist, naked. From the sculpture of ancient times onwards, the nude has been a formidable subject and justifiably takes its place in the training of students of art. But when the naked body you are portraying is the same one you know intimately, how much do you choose

to show? Do you distance yourself from your model or do you reveal your own sexuality in the way you portray your lover? The sensual and potentially erotic aspect of portraying the nude has, throughout history, greatly contributed towards the success of certain artists. Yet at one time depicting the personal and private was asking for trouble. John Ruskin famously claimed to have burned the erotic drawings of his hero J. M. W. Turner, stating they were 'shameful' and 'utterly inexcusable'. He believed Turner must have been insane when he drew them. As most of the drawings survive we may imagine Ruskin unable to light his bonfire. Had there been a couple making love before Turner's eyes or was he illustrating his own remembered experience?

Since his private life is shrouded in mystery, we must simply accept and respect the fact that the drawings were carefully hidden.

Certain taboo subjects either had to remain hidden or be clothed in respectability. Fernand Khnopff was said to be in love with his favourite model – his sister. His dreamily erotic images of her still give rise to speculation on the nature of their relationship. Frank Auerbach identified his long-term mistress in coded titles that included her initials with numbers. Andrew Wyeth produced over two hundred drawings and paintings of his neighbour, Helga Testorf, in complete secrecy over a period of fifteen years. Neither artist nor model told their respective spouses about their relationship. When the work was revealed to the world (appearing on the cover of *Time* magazine) their relations were deemed scandalous but the beautiful images, known as the 'Helga pictures', were celebrated.

Before its decriminalization in modern times, the subject of homosexuality could not make a comfortable public appearance in art. Leonardo da Vinci is renowned for his portrait of a noblewoman and his personal sexual leaning may never have been questioned if an accusation of sodomy against him was not known. Similarly, evidence of Caravaggio's presumed homosexuality is sought in his

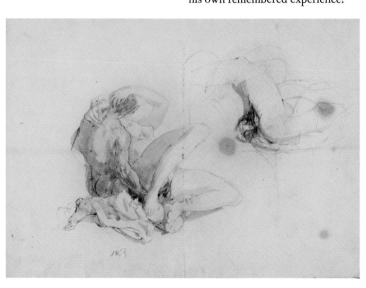

J. M. W. TURNER
*Erotic Figure Studies c.*1805
Watercolour on paper
Tate Gallery, London

FRANCIS BACON
Portrait of George Dyer Talking 1966
Oil on canvas, 198 x 147.5 cm
Private collection

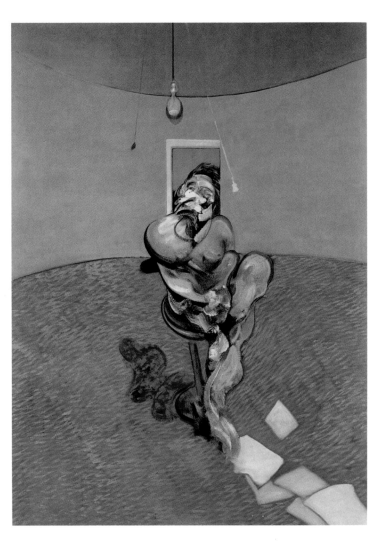

portrayal of beautiful, adolescent men. Giorgio Vasari, the Florentine biographer, mentions a portrait by Michelangelo of Tommaso dei Cavalieri, the young aristocrat with whom the artist developed a profoundly close relationship, revealed in correspondence. But where is this portrait? Tommaso's likeness has been 'detected' in the Sistine Chapel. Today we need not eagerly examine portraiture for sensational proof of hidden passion. Francis Bacon openly named his lover, George Dyer, in his paintings' titles. Their relationship was even explored in a film dramatization.

The philosopher Plato had much to say on sexuality in both men and women. He wrote at length about desire, the admiration of beauty and the spiritual aspects of love. To love was to be wise. He saw love as the means through which human beings could reach towards divinity. We often think of platonic love as non-sexual or something to do with being 'just good friends', yet friendship and companionship must be acknowledged and take their significant places within the context of love.

When looking at artists' portrayals of the people they loved, it is worth considering the effect the loved ones had on them later, through memory and even after death. Sandro Botticelli was buried, as he requested, at the feet of the noblewoman Simonetta Vespucci.

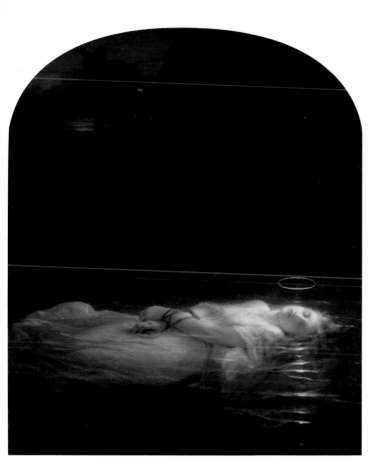

PAUL DELAROCHE
Young Christian Martyr 1855
Oil on canvas, 170 x 148 cm
Musée du Louvre, Paris

painted his wife as she died, 'almost mechanically observing the sequence of changing colours that death was imposing on her rigid face' as if to capture her likeness one final time. He kept the painting with him for the rest of his life.

In a recent show, Tracey Emin declared her disappointment in love: 'Christ I just wanted you to fuck me and then I became greedy, I wanted you to love me.' This stark accusation against an unidentified lover from her past appears in her own enlarged neon-lit handwriting for display upon a wall. Admission and self-revelation from artists can certainly help to illuminate the personal, emotional conditions under which they work. So often, looking to the past, we are mystified or mistaken through our lack of knowledge. Invariably, however, the portraits speak for themselves. Annie Liebovitz was encouraged to clarify her own relationship with Susan Sontag, finally stating 'it was a love story', though her striking photographs attest to this.

She had died over thirty years earlier. Is it her face, remembered by him, that appears in some of his portraits of young women as well as the celebrated Venus? Or is the repeated likeness his ideal of female beauty? Paul Delaroche painted his wife on her deathbed and again ten years later as a martyr, floating on water, her face lit by a saintly halo. Monet also

I considered many marvellous images before making my final selection of those people who were at some time loved by great artists. By celebrating their lovers, transforming their feelings into art, the artists have enabled us to peer into their hearts. So, through their achievement, their love endures.
Juliet Heslewood

Madonna of the Sacred Belt c.1456
Tempera on panel
Museo Civico, Galleria Comunale, Prato

FILIPPO LIPPI (c.1406–69)

Lucrezia Buti

Much that is known about fifteenth and sixteenth-century Italian art is thanks to the painter and historian Giorgio Vasari. He documented the artistic achievements of the Renaissance in his *Lives of the Artists*, a bestseller first published in 1550. Vasari writes about the fascinating story of the abduction of a nun by the monk painter, Filippo Lippi. He 'was asked by the nuns to paint the altarpiece for the high altar of Santa Margherita, and it was when he was working at this that he one day caught sight of the daughter of Francesco Buti of Florence who was living there as a novice or ward. Fra Filippo made advances to the girl . . . and he succeeded in persuading the nuns to let him use her as a model . . . This opportunity left him even more infatuated and by various ways and means he managed to steal her from the nuns.' Vasari states that the nun, Lucrezia, had a son, Filippino, who, like his father, became a celebrated painter.

Is it Lucrezia's face that appears in Lippi's altarpieces and frescoes?

His style has been described as 'sweet', acknowledging the loveliness of the women he portrayed, from the Virgin Mary to Salome. These faces at times resemble each other. The high forehead with scraped back hair was a contemporary ideal of beauty. Lippi, who was the teacher of Sandro Botticelli, was a master of linear drawing, using firm yet sinuous outlines. In the altarpiece for Santa Margherita, where he first met Lucrezia, it may well be her fine profile we see in his representation of the saint on the far left. This face bears a striking resemblance to the woman in his *Madonna and Child with Two Angels*.

A daughter, Alessandra, was born in 1465 and according to Vasari, the Pope was willing to release the couple from their religious vows. Lippi remained a popular artist and there were 'countless other artists to whom he affectionately taught the art of painting. He lived honourably from his work and he spent extravagantly on his love affairs, which he pursued all his life until the day he died.'

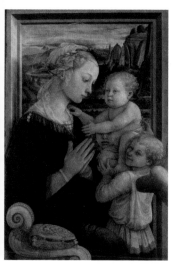

Madonna and Child with Two Angels c.1465
Tempera on panel, 95 x 62 cm
Galleria degli Uffizi, Florence

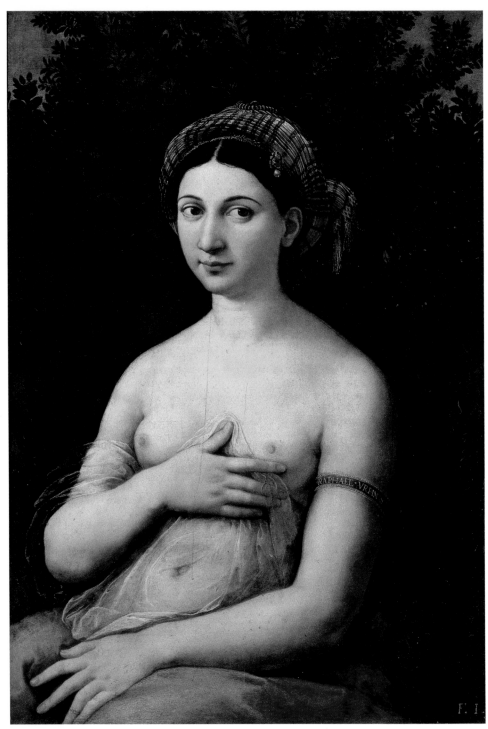

RAPHAEL SANZIO (1483–1520)

Margherita Luti

Was this lady Raphael's mistress? Giorgio Vasari, the artists' biographer, was a child when Raphael was still alive. Vasari evidently enjoyed discussing the private lives of artists and may well have exaggerated what he knew. He wrote at length about Raphael, often comparing his work with the great achievements of his contemporary, Michelangelo. He also claimed that Raphael 'kept up his secret love affairs and pursued his pleasures with no sense of moderation', going on to explain that 'on one occasion he went to excess, and he returned home afterwards with a violent fever which the doctors diagnosed as having been caused by heat-stroke.' Yet Vasari very definitely states that as Raphael was dying, he made his will 'and first, as a good Christian, he sent his mistress away, leaving her the means to live a decent life.'

The woman in this portrait is traditionally identified as the *Fornarina*, or baker's daughter, Margherita Luti, who lived in Rome at the time. Although her face is similar to other faces by Raphael of the Madonna, here the woman is undressed, suggesting a more intimate relationship. Her pose is not unlike the *Venus pudica* of classical statuary where a naked Venus has one hand hiding her genitalia and another at her breast, protecting her modesty. Here the pose seems more provocative. Raphael's woman wears an oriental, turban-style headdress that supports a decorative pearl hanging on her parted hair, a contemporary fashionable detail. The portrait, which is essentially a secular one, contains several references to love and attachment. Her left hand bears a ring on the marriage finger and the band around her upper arm carries Raphael's signature. *La Fornarina*, having been 'recognized' as the mistress Vasari mentions, became something of an icon for painters of later periods. The portrait was adapted in a variety of scenes showing Raphael with her at his studio. This theme of the artist and his model is a popular one, though it need not always imply a romantic association between the two. Whether this lady really was Raphael's mistress remains a tantalizing mystery.

*Portrait of a Young Woman
(La Fornarina) c.1518
Oil on panel, 85 x 60 cm
Galleria Nazionale d'Arte Antica, Rome*

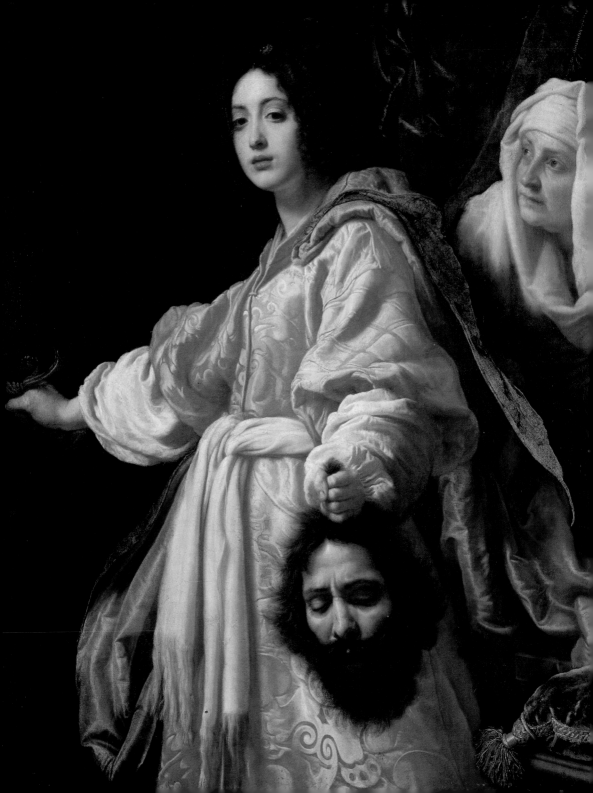

CRISTOFANO ALLORI (1577–1621)

La Mazzafirra

The terrible story of Judith and Holofernes comes from the apocryphal book of Judith. Subjects like this, that did not originate in the conventional canon of the Bible, offered artists the opportunity to depict dramatic and legendary tales that were welcomed by patrons for their extension of Christian themes. Judith, a wealthy, beautiful widow, was known for her religious devotion. She managed to dupe Holofernes, the leader of the Assyrian army, when he besieged her home town. She invited him to a feast and waited until he was drunk before chopping off his head. The next day the head was publicly displayed and used to drive away the invading army.

Allori was trained in Florentine painting techniques by his father who was also a painter. By the early seventeenth century, though Florence had produced students of genius (such as Michelangelo and da Vinci), Venice had gained its own distinction through artists' exploration of the use of colour. Allori's work, while being finely drawn and painted, shows his preference for the rich colours of Venetian art. In his depiction of Judith, her luxuriant clothing dominates the picture, revealing her social status. She is swathed in sumptuous drapes of red and gold which frame the hideous decapitated head of Holofernes. His expression is not that of a dead man but shows the distorted features of anguish and pain. Her beautiful face, looking out at us, is calm, almost smiling.

Allori made several versions of the painting and these two faces are said to be portraits of himself as Holofernes and his beautiful mistress, Mazzafirra, as Judith. She was the inspiration for many of his female characters including Mary Magdalene. Here it would seem his choice of subject relates to his own private torment. Their relationship was recorded by Filippo Baldinucci, a writer who succeeded Vasari as the biographer of celebrated artists. He described Allori's suffering at Mazzafirra's hands, her delight in spending his money and the terrible jealousy she inspired in him. As an image of a dramatically tempestuous relationship, the painting became popular and copies of it were frequently made in later centuries.

Judith with the Head of Holofernes c.1613
Oil on canvas, 125 x 100 cm
Galleria Palatina, Florence

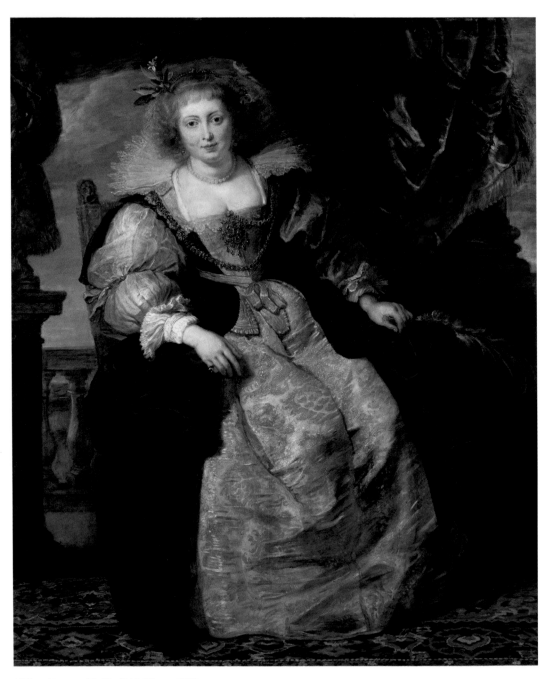

Hélène Fourment in Her Bridal Gown 1630
Oil on panel, 163.5 x 136.9 cm
Alte Pinakothek, Munich

PETER PAUL RUBENS (1577–1640)

Hélène Fourment

As court artist and royal ambassador, Rubens' outstanding career is unusual in the history of European art. His career blossomed in Antwerp where he carried out major commissions for the Church. Marie de Medici requested him to decorate the Palais de Luxembourg in Paris. In London he painted the ceilings at the Banqueting House in Whitehall for Charles I, who knighted him. At the time of his death he was working at the Torre de la Parada for Philip IV of Spain.

When working for himself he painted the people close to him. In 1609 he married Isabella Brandt who gave birth to three children. At her death he was unable to work for two seasons, despite the professional demands made on him. A few years later he was happy to marry sixteen-year-old Hélène Fourment, who was related to his first wife by marriage. Rubens was fifty-three at the time.

'I have decided to marry again, since I do not yet sense a tendency towards the continence of bachelordom,' he wrote. 'I have taken a wife from a good, though middle-class, house though everyone tried to convince me to establish a household within the aristocratic circles . . .'. The painting of Hélène in her wedding gown contains many elements of a majestic Baroque portrait. She did not belong to royalty, yet she sits inside a grand, classical-style balcony, surrounded by luxuriant drapes. Her dress takes up the larger part of the canvas and shows her attention to contemporary fashion in the semi-circular standing lace collar, billowing sleeves and tight, low bodice. Her face, with its pert, open expression and her pose, slightly leaning forward, convey her refreshing, unsophisticated personality.

Despite her young age and background, Hélène adapted well to her altered life in the country near Antwerp in a fine, new manor house. She posed for many of Rubens' paintings, whether of religious characters or mythological nudes. Giving birth to five children, she helped create a congenial home, enabling Rubens to state that he had 'no pretension in the world other than to live in peace'.

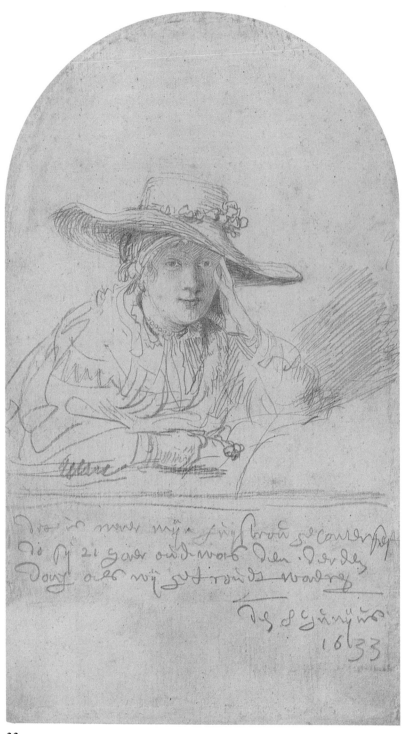

Portrait of Saskia van Uylenburgh 1633
Silverpoint on parchment,
18.5 x 10.7 cm
Staatliche Museen
Preussischer Kulturbesitz,
Kupferstichkabinett, Berlin

REMBRANDT VAN RIJN (1606–69)

Saskia van Uylenburgh

Rembrandt was a genius of western art and supreme master of Dutch painting. He painted deeply moving religious scenes, keenly observed contemporary events, landscapes and breathtaking portraits. As a young man he captured an image of his future wife in a small, personal and exquisite drawing. To acknowledge its significance, he scribbled at the bottom of the expensive piece of parchment paper, 'This is drawn after my wife, when she was 21 years old, the third day of our betrothal, the 8th June 1633'. They married just over a year later.

Rembrandt and Saskia met through her uncle, an art dealer, with whom Rembrandt worked in Amsterdam. They lived with him for over a year after their marriage. From this time, and throughout her short life, Rembrandt frequently drew or painted Saskia, using her name in the titles of his work, but also dressing her in the guises of legendary figures such as Danae or Flora. Just as he used his own face to examine the physiognomy of the ageing process, so he used Saskia as

the near-to-hand model of woman as female presence in the marital home. She is frequently shown in the intimate setting of the bed – asleep, lying awake or sitting still.

This drawing appears very natural, with Saskia leaning forward comfortably, her head resting on one hand. Despite the brevity of detail, Rembrandt carefully chose to include several significant elements. Rubens, a few years earlier, had painted his own bride in a garden, with straw hat and flowers. At this time the role of the shepherdess in art alluded to betrothal and marriage. Rembrandt gave Saskia a decorative, flower-strewn hat and instead of a crook, a single flower, perhaps a rose that as a token from him could symbolize their love.

Saskia died of tuberculosis a short while before her thirtieth birthday. She had given birth to four children, only one of whom, Titus, survived. Although Rembrandt was already successful when they married, earning his living mostly as a portrait painter, it was during their time together that his career flourished.

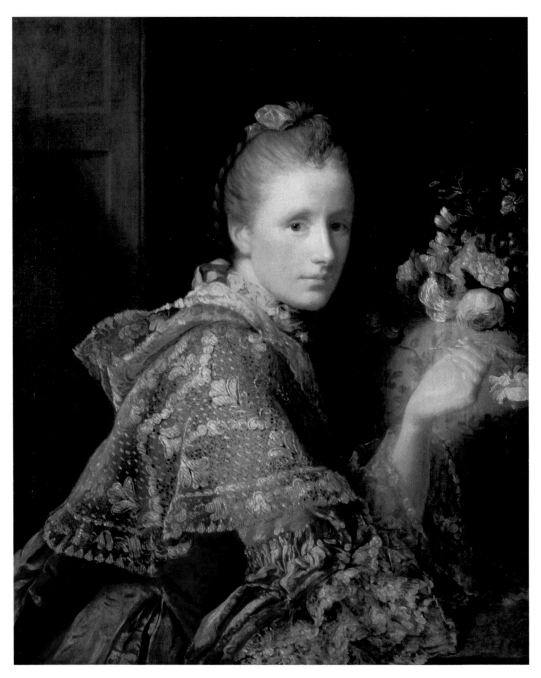

The painter's wife, Margaret Lindsay 1754–5
Oil on canvas, 76.2 x 63.5 cm
National Gallery of Scotland, Edinburgh

ALLAN RAMSAY (1713–84)

Margaret Lindsay

Allan Ramsay was a popular portrait painter not only because of his technical competence, but also because his polite manners and cultivated demeanour charmed his sitters. Members of the British aristocracy were happy to sit for him. He was only thirty years old when his first wife, Anne, died. One of the pupils to whom he gave drawing lessons was Margaret Lindsay, herself descended from Scottish nobility.

When they decided to marry, her father, Sir Alexander Lindsay of Evelick, refused permission. Despite his promising career, Ramsay's profession was not considered respectable enough. He refused to be deterred, claiming that he could provide Margaret with an income of £100 a year which was likely to become greater 'as my affairs increase, and I thank God, they are in a way increasing'. Still he was rejected. Perhaps Sir Alexander feared he was being opportunist, for Ramsay had to insist the reason for the marriage was 'my love for your Daughter, who, I am sensible, is entitled to much more than ever I shall have to bestow upon her'. The couple finally eloped and

were married on 1 March 1752 in the Canongate Kirk, Edinburgh. Her father's initial displeasure continued through their long and happy marriage. She gave him three grandchildren, but he never forgave his daughter.

Ramsay's portrait of Margaret is full of delicacy and shows the influence of contemporary French art with its emphasis on elegance and charm. Her own breeding is shown in her natural poise and tasteful clothes. Effortlessly, she leans slightly forward as she turns her head. Her shoulders are covered with fine lace that also spills from beneath her sleeves. Light falls on specific features – her face, the details of her clothes and a delicate bowl of roses.

Samuel Johnson said of Ramsay, 'You will not find a man in whose conversation there is more instruction, more information and more elegance.' He later became Principle Painter in Ordinary to King George III, a position that incited the jealousy of his contemporaries Joshua Reynolds and Thomas Gainsborough. This was one of the highest honours an artist of his day could achieve.

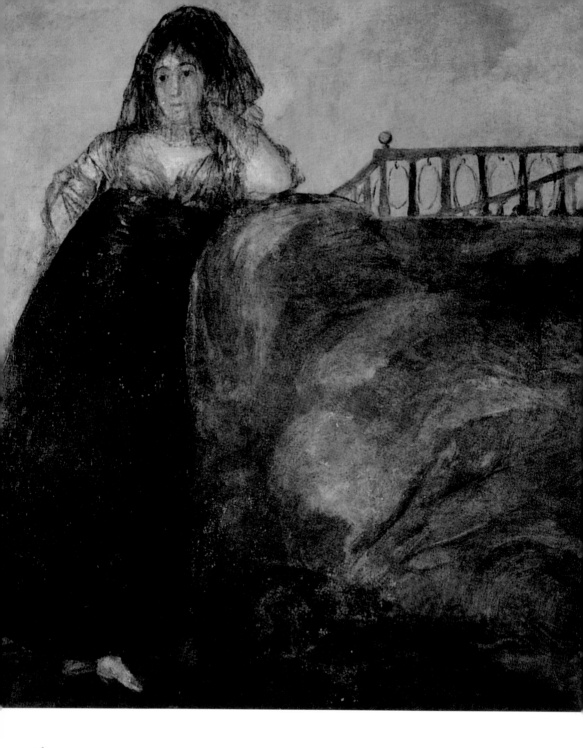

FRANCISCO GOYA (1746–1828)

Leocadia Weiss

As an eminent court painter Goya produced boldly realistic portraits of the Spanish royal family. In post-revolutionary Spain liberal thinkers were nervous of the continuing power of their despotic King, Ferdinand VII. Goya had witnessed his country suffer invasion and civil war and in 1824 he made his first visit to Bordeaux. The French port traded with Spain and some of his friends, the *afrancesados*, were living there.

During his voluntary exile there, Goya was joined by his housekeeper, Leocadia Weiss, who was referred to as 'his lady'. He was over seventy, a widower, and had been entirely deaf for more than thirty years. In his new environment he remained cheerful and, despite illness, actively painting. Goya was particularly fond of Leocadia's ten-year-old daughter, Rosario, who showed great promise in drawing, and may well have been his own child.

This painting came from his earlier Spanish home which had been named 'the House of the Deaf Man' even before he lived there. On its walls he had created private, self-expressive work characterized by dark, brooding colours that still confound and mystify today. Other Black Paintings, with their haunting, sinister overtones filled the same room. This portrait is presumed to be of Leocadia. It shows her as a pensive, black-veiled figure leaning on an indistinct mass that, together with the dark, outlined railings, suggest a tomb. If she does indeed lean on a tomb, is it Goya's own? Is he illustrating her future grief at his death?

X-ray analysis of the painting has revealed that where the supposed 'tomb' lies is an earlier representation of a mantelpiece and fireplace. In this version, the woman, with her face uncovered, strikes a natural pose with none of the harrowing imagery that occurs elsewhere in the room. Did Goya himself change the painting? If so, why?

Although, in a letter, he had sent her 'A thousand kisses and a thousand things from your affectionate Goya', Leocadia was excluded from his will when Goya died in Bordeaux. His son Javier went to great pains to secure his inheritance for himself and his own son, hoping Leocadia could be forgotten forever.

La Leocadia 1819–23
Oil transferred to canvas, 147 x 132 cm
Museo Nacional del Prado, Madrid

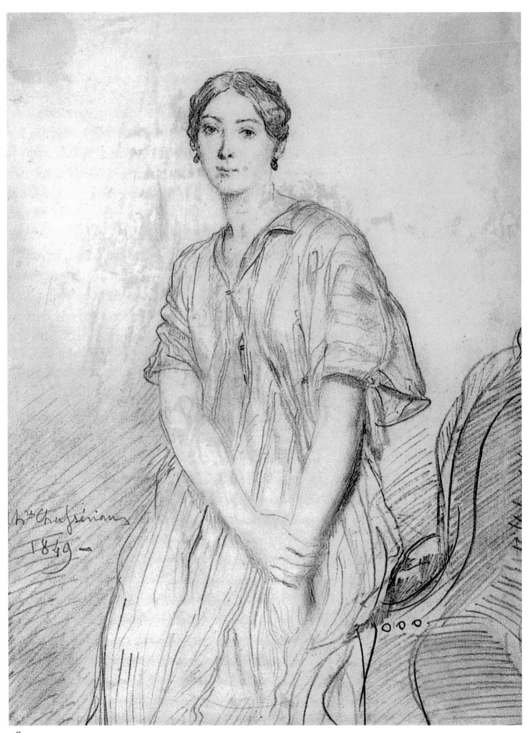

28

THEODORE CHASSERIAU
(1819–57)

Alice Ozy

Alice Ozy, an exquisitely beautiful actress, became the mistress of several celebrated personalities in mid-nineteenth-century Paris. As her career on the stage advanced, she was able to count among her lovers the Duc d'Aumale (the son of King Louis-Philippe) as well as the son of Victor Hugo, whom she preferred to his father. While she can be identified in contemporary written descriptions of dazzling women, Chassériau's canvasses and pencil drawings of her immediately convey her fine, yet voluptuous, beauty.

At the age of eleven, Chassériau became a pupil of the eminent artist Jean Auguste Dominique Ingres who is said to have declared 'this child will be the Napoleon of painting'. At twenty-five Chassériau became director of the French Academy in Rome. Although he gained success as a painter of historical and religious themes, as well as in portraiture, he depicted the female nude with a highly personalized, romantic eroticism, largely due to his admiration for the work of Eugène Delacroix. Ingres was disappointed with this development but the writer Théodore Gautier championed Chassériau's work and

it was probably through him that he was introduced to Alice.

She soon chose him as a lover and during the two years they were together Alice posed as the leading lady in some of his more sensual depictions of nudes. In this portrait his drawing style, learned from Ingres, shows a concentration of detail in her lovely face, capturing her expression perfectly, while her arms and clothing are more summarily treated.

The end of their affair was prompted by Alice demanding a certain painting as a gift. It was one that Ingres had admired, telling Chassériau never to part with it. Once she owned it, she teased her lover for having broken his promise to Ingres. Incensed with anger, he slashed it with a knife and broke off their relations, never to be reunited. Victor Hugo portrayed the lovers unkindly in his posthumously published novel *Choses Vues*: Alice was fiery Zubiri and Chassériau was Serio, who was as ugly as a monkey.

Chassériau was not yet forty when he died. Alice, being comfortably off, collected his work and gave an early painting to the Louvre.

Portrait of Alice Ozy 1849
Graphite on paper, 32.1 x 24 cm
Musée Carnavalet, Paris

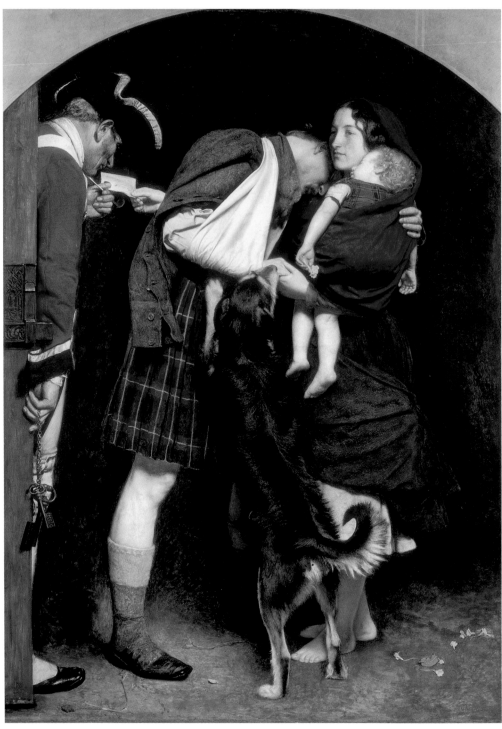

JOHN EVERETT MILLAIS (1829–96)

Effie Gray

The Order of Release, 1746 1853
Oil on canvas, 102.9 x 73.7 cm
Tate Gallery, London

When the group of young painters known as the Pre-Raphaelite Brotherhood were struggling for recognition, their cause was championed by the eminent Victorian art critic, John Ruskin. He advised them to look carefully at nature and to copy it exactly. He asked John Millais to paint a portrait of himself standing on the gneiss rocks near a waterfall on the River Turk in Scotland. Millais studied the scene meticulously and as well as his fine portrait, he painted Ruskin's wife, Effie, sitting nearby on the same rocks of the wild landscape. Her outline forms a continuum with the rocks but the vivid red fabric she is stitching singles her out. Landscape painting would become a favorite subject for Millais later in his career.

Millais and Effie grew closer and soon acknowledged their deep love for one another. For years the three suffered the indignation of public attention and finally Ruskin was shamed by his divorce which was on the grounds of non-consummation. Effie later wrote to her father: 'He alleged various reasons, hatred to children, religious motives, a desire to preserve my beauty, and, finally this last year told me his true reason . . . that he had imagined women were quite different to what he saw I was, and that the reason he did not make me his Wife was because he was disgusted with my person the first evening . . .'. Queen Victoria refused to allow Effie in her presence although Millais rose to become one of the most celebrated portrait painters of his day and the first artist to be made a baronet.

Effie and Millais were finally married and led a happy life together, producing eight children. The Pre-Raphaelites often used friends and family as models to create realistic portraits in their narrative paintings. In *The Order of Release, 1746* Millais painted Effie, who herself was Scots, as the wife of a rebel prisoner during the Jacobite uprising. Her child sleeps inside her shawl. As she hands the notice over to a soldier, her face triumphant and proud, she secures her husband's freedom and their future life together.

A Waterfall in Glenfinlas 1853
Oil on panel, 26.7 x 31.8 cm
Delaware Art Museum, Wilmington

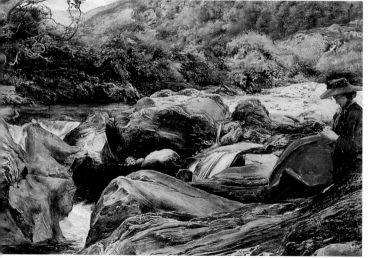

31

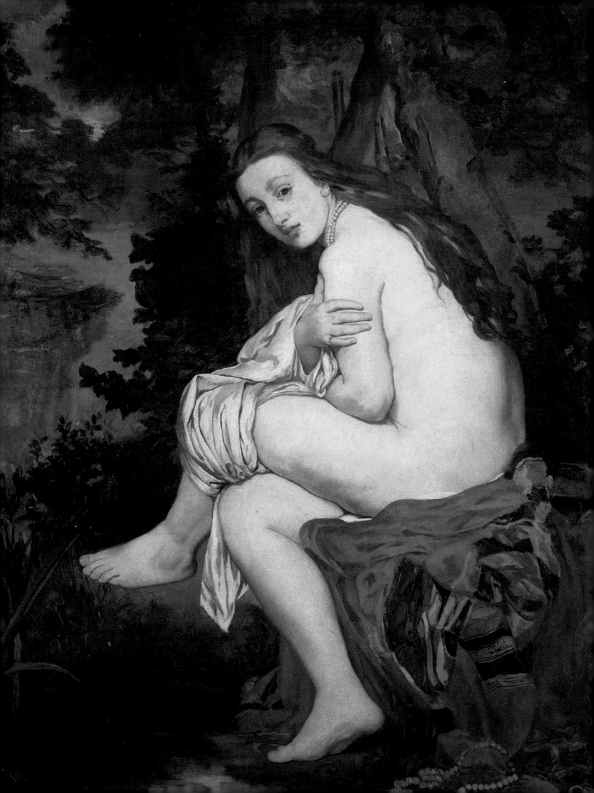

EDOUARD MANET (1832–83)

Suzanne Leenhoff

Illustrating contemporary Paris was, in the 1860s, a new idea and hardly acceptable within official art circles. Manet, who was born and died in the city, throughout his life painted its streets, cafés and lively society. He was considered the leading figure of the rebellious band of painters we now admire as the Impressionists. They were intent on representing the real world, not an imagined one of historical or mythological scenes that was popular at the time. They found in their own families, their homes, the city and the country an immediate wealth of subject matter. Among the group's varied members, Manet was described as a 'dandy', probably because of his bourgeois background of education and privilege. Marcel Proust claimed that although Manet affected the character of a bohemian, he always appeared aristocratic.

Manet's family household was highly cultivated and it was here that a young Dutch woman, Suzanne Leenhoff, came to teach the piano. In 1852 she gave birth to a son who lived with her as her younger brother. Suzanne often modelled for Manet and when his father died,

they were married. It is presumed that Manet was finally legitimizing his relationship with Suzanne and his own child after years of keeping their liaison secret.

In the painting of the nymph, Manet reveals his interest in conventional artistic themes and the art of the past. Suzanne, her plumpness exposed, is more like a Rubens nude than an Impressionist mistress. An earlier study of the work shows that two other figures were planned, suggesting the apocryphal theme of Susanna who, while bathing, was surprised by two Elders who threatened to accuse her of adultery. The nude in this imaginary context, her pale flesh emphasised by the dark woodland behind her, was more acceptable than the modern naked girl he later painted in his *Déjeuner sur l'Herbe*, sitting amongst clothed men at a picnic.

As she grew older Suzanne's size also grew. One friend described her as the 'fat, placid Dutchwoman' and Manet began to paint her less often. Yet in sophisticated or artistic circles, she was praised for her kindness, her warmth and her remarkable ability to remain calm.

The Surprised Nymph 1861
Oil on canvas, 146 x 114 cm
Museo Nacional de Bellas Artes, Buenos Aires

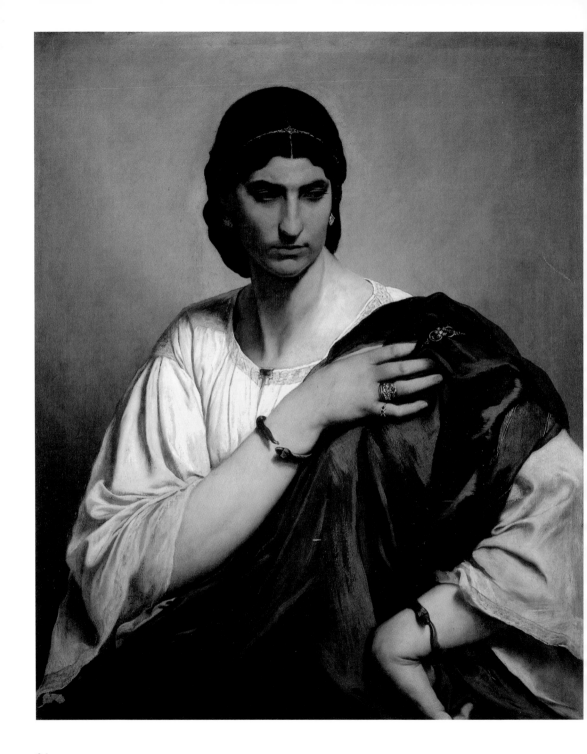

ANSELM FEUERBACH (1829–80)

Anna 'Nanni' Risi

Rome, in the mid-nineteenth century, was the place where many artists hoped to perfect their professional artistic education. Not only were there examples of painting, sculpture and architecture from the Renaissance, but also a wealth of material surviving from the city's origins. Roman artefacts provided artists with the means to study the classical period at first hand rather than through plaster casts in academy studios.

It was to Rome that the painter Feuerbach came, having studied at home in Germany as well as in Paris. The art of Italy overwhelmed him and he settled there for seventeen years, during which time he produced his most famous works. In 1860 he met the wife of a cobbler, Anna Risi, known as 'Nanni' to several artists, including Lord Frederick Leighton, who made her a popular model. Her strong, chiselled features and statuesque physique embodied their idea of ancient beauty.

Feuerbach fell instantly in love with her. She was willing to leave her husband and son in order to be with him and she became the subject of many of his striking portraits inspired by historical themes. Time and again she can be seen sitting still, poised, pensive – the romantic heroine of age-old drama. In the painting known as *Lucrezia Borgia* her downcast eyes and uncertain smile as well as her smooth, dark hair and rich drapery lend mysterious weight to Feuerbach's perception of the celebrated and cruel femme fatale. In reality Lucrezia was said to have had long blonde hair. Here and in other representations of Nanni she wears heavy jewellery, probably copies of the many gifts Feuerbach willingly gave her. A letter to his mother in 1864 suggests she thought his extravagance towards his lover was excessive.

For a time Nanni left Feuerbach, preferring the attention of a wealthy Englishman with whom she lived briefly in southern Italy. When she returned, seeking reconciliation with Feuerbach, he refused. He was able to tell his mother that although she was impoverished, he had managed to wave her away into the distance, back into the Roman streets where she had first accosted him.

Lucrezia Borgia 1866
Oil on canvas, 98 x 81 cm
Städelsches Kunstinstitut, Frankfurt

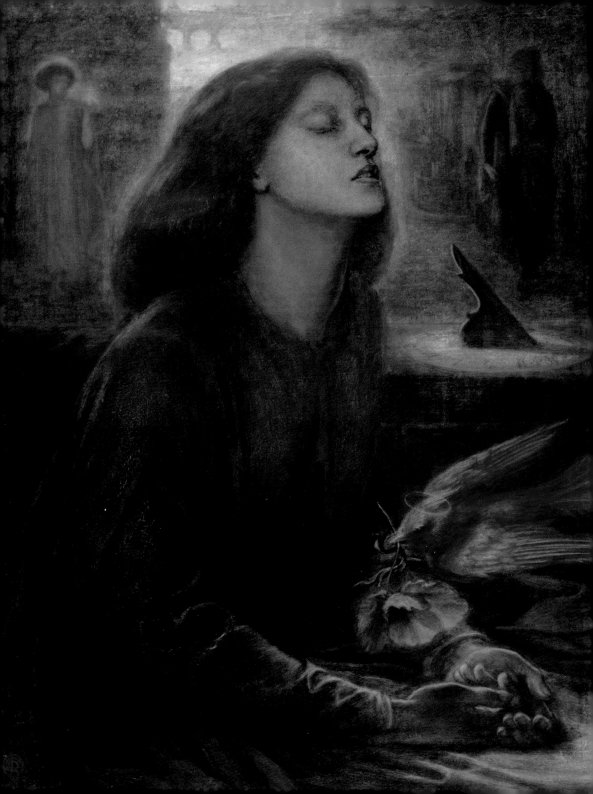

DANTE GABRIEL ROSSETTI
(1828–82)

Lizzie Siddal

In his early career Rossetti often used his friends and family as models for his narrative paintings. Real portraiture could give authenticity to the appearances of characters in literary themes. One of his models, also used by other Pre-Raphaelite painters, was Lizzie Siddal. She had been discovered working in a milliner's shop in Leicester Square. A tall woman with fine, slender features, her unusual appearance was unlike the more saccharine ideal of contemporary Victorian beauty. For Rossetti and his friends, Lizzie was 'a stunner'. Millais chose her to pose for Ophelia in his celebrated painting of Shakespeare's sad, disturbed heroine.

Lizzie became Rossetti's muse, yet the intensity of their relationship is hardly reflected in his paintings for which she posed. She did not conform to Rossetti's preference for fleshy, more overtly sensuous women, such as Jane Morris. Rossetti elevated her in his imagination, associating her with a real person from the past. She became Beatrice, the great love of the Italian medieval poet, Dante Alighieri, with whom he himself identified.

By the time the couple were married, Lizzie was already addicted to laudanum. She suffered a stillbirth and became profoundly depressed. She died not long afterwards, possibly from an overdose. In this portrait, based on earlier drawings of Lizzie, the drug is aluded to as a white poppy carried by the bird, a messenger of death. The Pre-Raphaelites often included symbolic motifs in their work, allowing them to be read on a deeper level.

Rossetti's title refers to his Beatrice becoming 'beatified'. At the same time his own Lizzie becomes entirely romanticized. In the Florentine streets behind Beatrice stands Dante, gazing towards the figure of Love who turns away from him. 'On the sundial at her side the shadow falls on the hour of nine, which number Dante connects mystically in many ways with her death,' Rossetti explained.

Though she was a gifted artist herself, encouraged by the influential art critic John Ruskin, her fame has evolved through her husband's vision of her. He buried a book of his poems in her coffin which, years later, he asked to be exhumed. Legend has it that her hair filled the coffin and her body had remained unchanged.

Beata Beatrix 1864–70
Oil on canvas, 86.4 x 66 cm
Tate Gallery, London

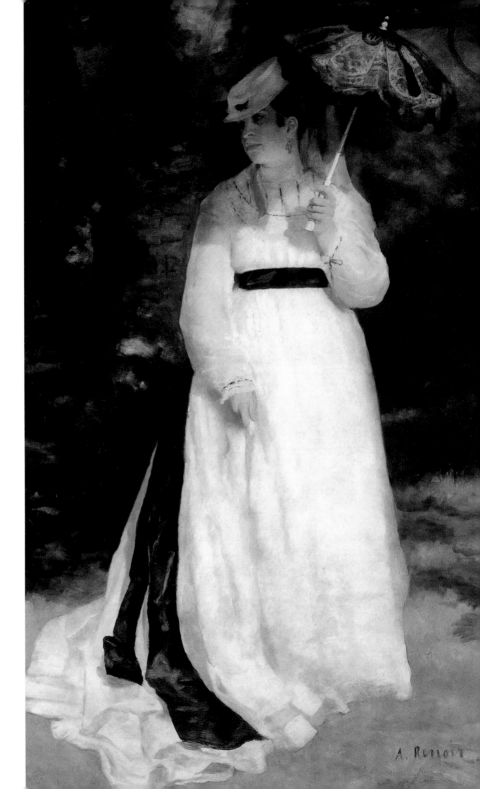

PIERRE-AUGUSTE RENOIR
(1841–1919)

Lise Tréhot

Lise with a Parasol 1867
Oil on canvas, 181.6 x 113 cm
Folkwang Museum, Essen

Fontainebleau Forest, a short rail journey from Paris, for years provided painters with a beautiful, rural location where they developed their painting *en plein air* – out of doors. This was a practice that the Impressionists preferred to working in the studio. Outside they could study natural light and paint what they saw directly onto their canvasses. Renoir, whilst staying with a friend who lived near the forest, met Lise, a dark, attractive seventeen-year-old. She soon became his lover and model.

It was essential for aspiring artists of the time to exhibit at the Paris Salon. In 1867 Renoir submitted a painting of Lise as the goddess of the forest, Diana, showing her with a killed deer at her feet. The mythological subject, acceptable to the Salon jury, did not meet with their approval since her nudity was hardly that of an ideal divinity. For their taste she was too much a real, live, modern woman.

Renoir at last gained recognition at the Salon of 1868 with a more natural rendering of Lise. It shows her standing still beneath a shady tree carrying a parasol with her face in shadow. Her light-textured, white dress with its contrasting black sash is in full sunlight, providing a delicate and very feminine image. At the same time Claude Monet was painting similarly well-dressed figures in the forest, mostly modelled by his own lover, Camille.

Despite its success, the painting came under fire from the critics. In one paper Lise was cruelly described as a big, runny cheese of perfect consistency and was caricatured by a sketch of the cheese standing in front of the tree.

Lise continued to sit for many of Renoir's early works including *Woman of Algiers*, where she took on an exotic guise. In 1872 she married a young architect and it is said she never saw Renoir again, nor was he inclined to return to Fontainebleau. Years later, when their relationship was well known, though she kept the paintings he had given her, she destroyed all trace of personal letters, papers and photographs that were associated with Renoir.

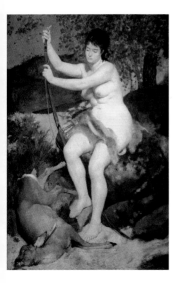

Diana 1867
Oil on canvas, 199.5 x 129.5 cm
National Gallery of Art, Washington D.C.

The Kiss 1868
Oil on canvas, 92 x 91 cm
Palais des Beaux Arts, Lille

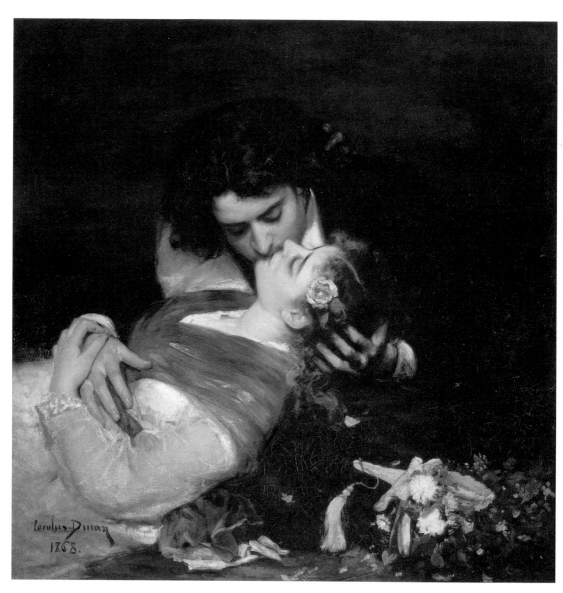

CHARLES AUGUSTE EMILE DURAN (CAROLUS-DURAN) (1837–1917)

Pauline-Marie-Charlotte Croizette

'I love, with all my soul, a young girl who, I believe, suits me well. We have known each other for three months and this beautiful, gentle love is going to crescendo. We feel that it would be impossible to live one without the other . . . we both wish to be married as soon as possible,' wrote the artist, Carolus-Duran, to his widowed mother in January 1868, asking for her consent. 'Give it to me immediately, that is, by return of post so that I can publish the banns straight away and marry in a fortnight at the latest . . .'. His mother consented within four days and they were married at the end of the month.

Pauline-Marie-Charlotte was a miniaturist and pastel painter who had been exhibiting portraits for some years and, like many artists, was studying at the Louvre. The lovers had met at the great museum the previous October. Carolus-Duran's beautiful, sensuous painting, done at the time of their marriage, is charged with romantic feeling. The man is recognizable as the artist from other self-portraits. His face meets hers at the centre of the canvas, their eyes almost closed, their mouths only just touching. Their hands hold each other's heads and are gently clasped beneath her breast. The darkness of the background contrasts with the light tones of her dress while the deep red shawl and rose bring warmth to the strikingly coloured palette. The bouquet of flowers, laid aside as they kiss, picks up the flesh tones while adding an essentially feminine delicacy to this intimate portrayal.

Carolus-Duran found his wife a constant inspiration during their happy marriage. A year later he portrayed her in a very different painting, *Woman with a glove*, which received great critical acclaim at the Paris Salon. The formality of the dignified pose and the dark tones are lightened by the presence of a pale glove she has just let fall to the floor. In 1873 he created a sensation by presenting Pauline-Marie-Charlotte as a bronze bust, prompting one critic to say, 'it is Roman woman rejuvenated by the artist's flame'.

Woman with a glove 1869
Oil on canvas, 228 x 164 cm
Musée d'Orsay, Paris

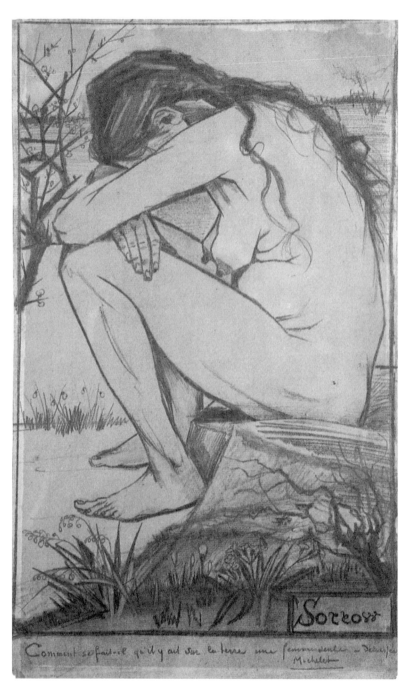

Sorrow 1882
Pencil and black chalk on paper, 44.5 x 27 cm
Walsall Museum and Art Gallery, Walsall, Garman-Ryan Collection

VINCENT VAN GOGH (1853–91)

Sien Hoornik

The young Vincent Van Gogh hoped to become a preacher like his father. After failing to enter the Church, he believed he could preach the gospel and teach others through art. His early subjects included peasants working the land in a style reminiscent of the realist painter Jean-François Millet, whom he admired.

Throughout his life he wrote to his younger brother Theo who once said of Vincent, '. . . his heart is so big that he is constantly trying to do things for others'. In 1882, when he had begun drawing lessons, Van Gogh met Sien Hoornik, a pregnant prostitute and mother of a young daughter. Despite great opposition, he took them into his home and dreamed of marriage and family life.

'I am longing to know what impression Sien will make on you,' he told Theo, who was supporting him financially. 'There is nothing special about her, she is just an ordinary woman of the people who has something of the sublime for me. Whoever loves a plain, ordinary person and has endeared himself to her is happy – despite the dark side of life. Had she not needed help last winter then the bond between her and me would not have been forged in the circumstances.'

In *Sorrow*, the English title he gave the drawing, Van Gogh depicts Sien in a pose that illustrates both her plight and his profound feelings for her. Without flattery he shows the thin yet pregnant woman starkly naked, hiding her face, sitting in a bleak landscape, though spring flowers grow at her feet. There are several versions of the drawing and in one Van Gogh quoted from a treatise entitled 'La Femme' by the historian Jules Michelet: 'How is it that there is, on earth, a woman alone?' Van Gogh added to it the word 'abandoned'.

Van Gogh was unable to sustain his domestic life with Sien but continued with his mission of painting. His first masterpiece, *The Potato Eaters*, was a dark scene of peasant poverty. In 1887, with Theo's continued support, he arrived in Paris. Here, in a new environment, he discovered the Impressionists and the sombre moods and colours of his early work began to disappear.

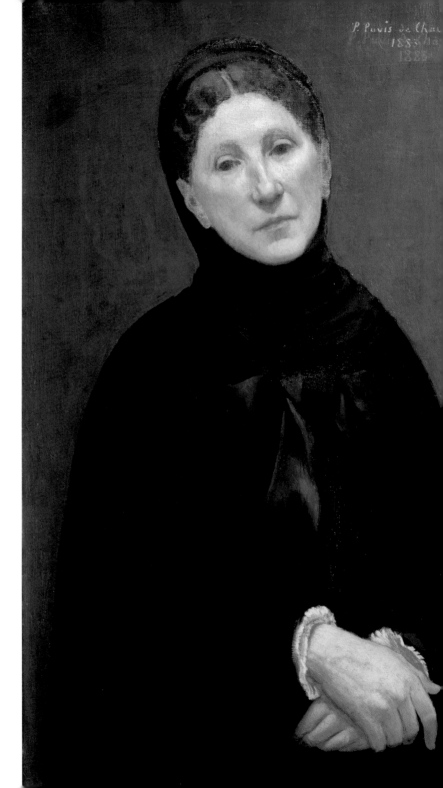

44

PIERRE PUVIS DE CHAVANNES
(1824–98)

Princess Marie Cantacuzène

Princess Marie gained her royal title through her second marriage, to her cousin, whom she subsequently left. She arrived in Paris in 1850 and though of ancient nobility in her own right, she actively looked for work, presumably to support herself. She became an artist's model. At this time artists worked mostly in the studio. Models were frequently required to pose for paintings of historical or mythological scenes. Princess Marie joined Théodore Chassériau's studio and through him met Puvis de Chavannes. His career was just beginning and he later became a highly influential painter of large, public narrative scenes and smaller symbolic works. His nudes were based on conventional, classical models.

Princess Marie was to become more than just a model for Puvis; she became his life-long friend. The portrait of her aged in her sixties appears sombre at first, her expression unsmiling, even distant. Her pale face and hands are framed by very dark clothing suggestive of widows' mourning wear. When it was shown at the Salon, Puvis vehemently denied this reading of

the work: 'This person is not a widow and if the expression of her face is sad, it is I who am guilty of having involuntarily stressed this side of her. She has a serious, very high-minded and very kindly character. My only excuse is that I have often seen her with this pensive attitude that has misled you. Reflective people don't think gaily . . .'.

When his biography was being written, Puvis insisted that a whole chapter should be devoted to Princess Marie, describing her influence on both himself and Chassériau. Professionally she was a reliable model who possessed innate decorum. Personally she devotedly cared for Puvis as he grew older. They were both in their seventies when they married in 1897 (her husband had died over a decade earlier) and were described as being 'linked in extremis'. Princess Marie died two months before Puvis, having bequeathed the portrait to the museum in Lyon, his birthplace. The young Van Gogh saw it in an exhibition and admired its great dignity. He wrote that 'there is no such thing as an old woman.'

Portrait of the artist's wife,
Madame de Chavannes 1883
Oil on canvas, 78 x 46 cm
Musée des Beaux-Arts, Lyon

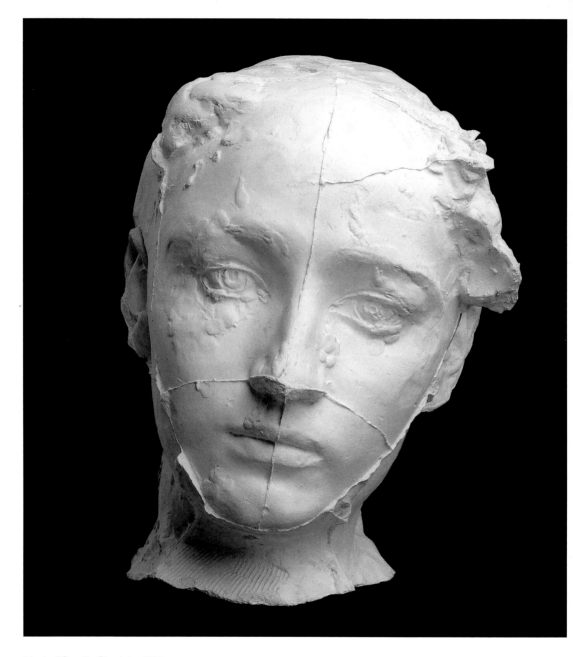

*Mask of Camille Claudel c.*1884
Plaster, 22.8 x 17 x 16 cm
Musée Rodin, Paris

AUGUSTE RODIN (1840–1917)

Camille Claudel

As his career flourished Rodin found he preferred portraying the people who were close to him to more formal commissioned work. Camille Claudel met Rodin in 1883 and came to study in his busy workshop the following year, from which time he began to model her face. Her haunting features appear time and time again throughout the long period of their passionate relationship and even afterwards. Mutual professional admiration lay at the roots of their attraction for each other, but their differences in age, status and public recognition were to jeopardise the liaison. Rodin refused to live permanently with Camille and remained with Rose Beuret, the mother of his son, who was fully aware of his infidelity.

In creating works of sculpture that are moulded, not carved directly from solid material like stone or marble, the plaster mask is the next stage on from a clay model. Bronze casting is a likely end result though sometimes not realized, leaving the work of plaster as final. This early mask (which can be seen in a photograph of Rodin's studio of 1887) is not unlike another that was probably taken from the same clay model. In it Camille wears a turban. It was later produced in terracotta, bronze and compressed glass.

During the period of their intense affair, both Rodin and Camille created highly original sculptures depicting amorous couples. These are full of vigorous movement and express the power and beauty of physical passion. Because of their professional and personal proximity, the attribution of works to either artist has occasionally proved difficult.

Rodin acknowledged Camille's genius and encouraged it, but he decided to stay with Rose as his domestic companion. Though he suffered from the separation with Camille, he held on to the image of her face with its distant stare and delicate features, transforming it into allegorical subjects such as Dawn, Thought, St. George, France, The Farewell . . .

When Rodin and Rose were in their seventies, not long before they both died, they finally married. Meanwhile Camille Claudel had been incarcerated in a psychiatric asylum for over four years.

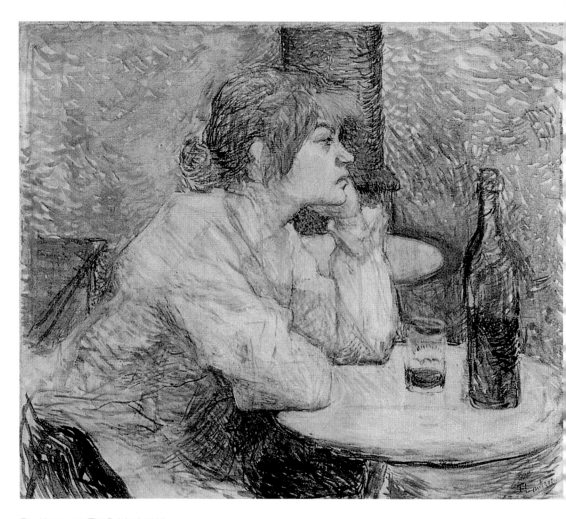

The Hangover (The Drinker) 1888
Oil and chalk on canvas, 47.1 x 55.5 cm
Fogg Art Museum, Harvard University, Cambridge, Massachusetts

HENRI DE TOULOUSE-LAUTREC
(1864–1901)

Suzanne Valadon

As the son of wealthy aristocrats, Lautrec did not need to work. The closeness of his parents' relationship (they were first cousins) probably contributed to his severe physical disability. During his childhood he suffered from two falls and broke each leg. He was encouraged to draw and paint to keep him cheerful and later decided to become a professional artist. His family knew that Paris would provide him with the relevant training but was horrified when his favourite subjects were seen to come from the scandalous world of Montmartre.

Lautrec may have been physically deformed but he had an engaging personality that made him very popular. He felt at home in the cafés, cabarets and brothels of Montmartre. His work helped bring celebrity to some of the area's most colourful personalities and they, in turn, did the same for him. Suzanne Valadon, a laundress's daughter, was one of his circle of bohemian friends. With striking eyes and a face full of expression, she became the favourite model of many artists including Pierre Puvis de Chavannes and Auguste Renoir.

She lived with her mother and son in the same building as Lautrec and for several years she modelled for him, taking her place among his many striking portraits of Montmartre's characters. Lautrec had a café table placed in his studio which is probably where Valadon sat for this fine portrait. She is not identified as his lover or friend, nor does the title, *The Hangover*, suggest he knows her. She becomes one of many impoverished women who have taken to drink for companionship. His lively brushstrokes (once described as 'chopped vegetables') reveal the rapidity of his technique which helped him to capture the sights and atmosphere of bustling, public places.

Although he was nourished by the company of struggling entertainers or prostitutes, it is thought that Valadon was Lautrec's only real love. But when she and her mother plotted a fake suicide threat, to force him to marry her, he broke off their relations. Living in Paris at a time when it was the centre of European artistic activity, Valadon herself became a significant painter as did her son, the artist Maurice Utrillo.

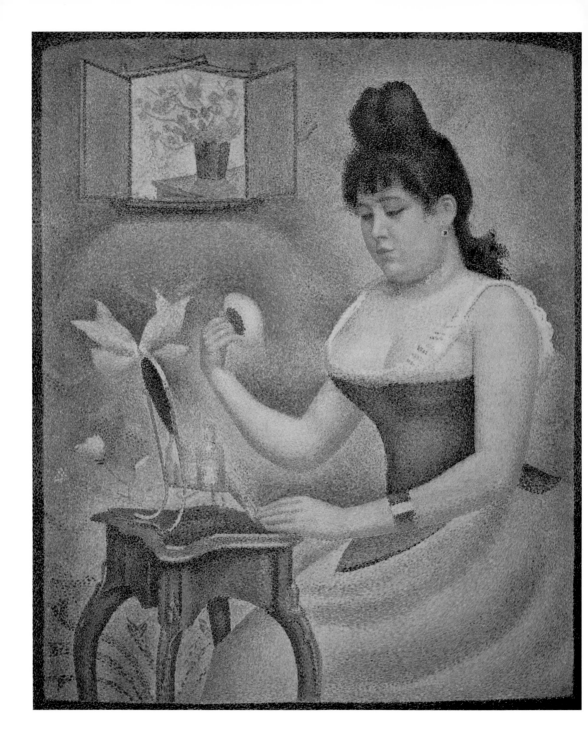

GEORGES SEURAT (1859–91)

Madeleine Knobloch

At the age of twenty-four Seurat set the scene for his future career when he exhibited a huge painting that shocked art critics and the public alike. *Bathers at Asnières* revealed his meticulous, scientifically-based technique to an uncomprehending world. Together with other like-minded painters who had suffered rejection, he struck out alone, exhibiting in a disused post office building to inaugurate the Salon des Artistes Indépendents.

He was a secretive young man. His public, professional self was the talk of Paris, but he hid his private world from view. In the north of the city, not far from Montmartre, he shared his life with a young model, Madeleine Knobloch. In this domestic portrait he does not name the young woman in the title, yet reveals a closeness to her as she pauses in her dressing to attend to her face. Few other works by Seurat reveal such an intimate scene.

The surface of the canvas is smothered by brushstrokes applied in tiny dots. This technique, known as pointillism, developed from a knowledge of colour theories and the study of the effect that one colour has upon another when placed in close proximity. Seurat carefully developed his own colour schemes so that when looking at the mass of tiny, individual strokes from a distance they blend into pleasing harmonies. Here the paint reaches out to a framework around the scene so that the true frame need not create a disparity with the colours of the portrait.

If Madeleine appears stiff it is probably because of the lack of spontaneity these methods demanded. Seurat carefully placed her to one side of the picture, the furnishings of her boudoir to the other, in order to create a composition of lively, interesting shapes.

In the same year as the portrait was painted Madeleine gave birth to their son. Seurat did not introduce his small family to his parents until a year later. In 1891 Seurat died unexpectedly of an infectious disease that also killed his son some months later. His promising career was brutally cut short, but his influence had already been established.

Young Woman Powdering Herself c.1890
Oil on canvas, 95.5 x 79.5 cm
Samuel Courtauld Trust, The Courtauld Gallery, London

GIOVANNI SEGANTINI (1858–99)

Bice Bugatti

The life of the mountains, its scenery, its people and their work, its animals and flowers, can be found in Segantini's magnificent, fresh, light-filled paintings. His broad yet meticulous studies of glistening snow-covered peaks and grassy meadows place him in a unique position as the true painter of the Alps. Though bordering on the sentimental, his views show his pantheistic reverence for nature: 'I have God inside me. I don't need to go to church,' he said. Despite a difficult childhood as an orphan (including escaping from a reformatory), his early successes in Milan decided his future as an artist. He chose a pointillist technique, being used by many artists at the time. It enabled him to convey the sparkling colour and clear air of his chosen, rural environment.

In 1880 he met Beatrice 'Bice' Bugatti who was to become his life-long lover and mother of his four children. Together they lived mostly in mountain villages. When away from Bice he wrote her love letters, sometimes perfumed with flowers he had picked. 'Take these unsightly flowers, these violets, as the symbol of my great love,' he wrote after they had been together ten years, 'I picked them only thinking of you. When a spring once comes in which I fail to send you such violets, you will no longer find me among the living.'

His painting of Bice, like many of his other works, is composed of natural imagery yet is essentially symbolic. Beneath its surface was a picture entitled *Phthisis* (tuberculosis) for which Bice was also the model. Segantini chooses not to emphasise the negative aspect of the illness, but shows her on the brink of recovery. A small, devotional cross stands above her brightly lit pillow. The rose petal is evoked in the bloom of her pink cheeks. The picture's suffused glow comes from his use of gold leaf which he painted onto it then scratched. Segantini's lengthy correspondence reveals his concern to present the painting more as a Symbolist work than as a portrait, and its success lies in his simple means of conveying the triumph of life over death.

Rose Petal 1889–91
Oil, tempera and gold leaf on canvas,
64 x 50 cm
Private collection

MAURICE DENIS (1870–1943)

Marthe Meurier

'Remember that a picture, before being a battlehorse, a nude, an anecdote or whatever, is essentially a flat surface covered with colours arranged in a certain order.' This definition, given by Maurice Denis in 1890, offered a different way to approach a work of art, one that was being explored and practised by his contemporaries. He wanted to emphasise the flatness of a picture's two-dimensional surface as well as its decorative potential and in doing so, helped pave the way towards modern art. With like-minded friends he formed a group known as the Nabis, the word *Nabi* based on a Hebrew word for 'prophet'.

In his painting of his fiancée Marthe at the piano, the emphasis on decoration is revealed in the individuality of the separate components. The patterned wallpaper, the contrasting pale music score, the shapely curves of her apron and dark dress all have their 'flatness' emphasized through a lack of shadow. The space between each element is not defined, but understood. In this way a whole decorative pattern is achieved.

Denis met Marthe in 1890 and was soon writing ecstatically in his diary about his feelings for her. She became the central figure, almost an icon, in his work. Her easily identifiable, pretty face peered from domestic or allegorical scenes. As Sancta Martha in one painting she is about to serve a plate of fish to Christ and the apostles. 'From her I have regained the naïvete of faith, the joy of being good without sadness, a clear idea of a better world. From her, I will regain the gift of tears and the madness of true hope.'

Marthe shared her love of music with Denis and although the title on the score refers to a piece by Maeterlinck, the minuet was written by a friend. Denis uses the cover's motifs to symbolize spiritual aspects of Marthe. A woman bends to pick flowers from the earth while another, nude, reaches to the sky. Denis' work in its entirety ranges between religious and secular subject matter.

The lovers were married in 1893 and had seven children, many of whom were seen with Marthe in images entitled *Maternity*.

Minuet of Princess Maleine or
Marthe at the Piano 1891
Oil on canvas, 95 x 60 cm
Musée d'Orsay, Paris

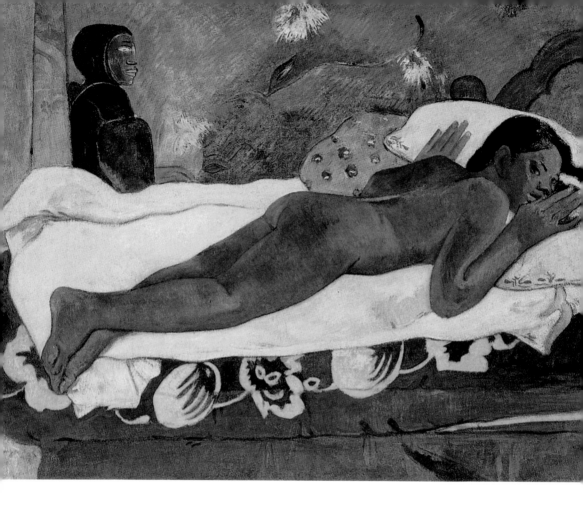

Manaò tupapaú (The Spirit of the Dead keeps watch) 1892
Oil on canvas, 73 x 92 cm
Albright-Knox Art Gallery, Buffalo

PAUL GAUGUIN (1848–1903)

Tehura

All his life Gauguin travelled. Much of his childhood was spent in Peru and as a young sailor he visited Brazil, Chile, Scandinavia and the Mediterranean. Having given up his conventional job in the Paris stock market to become a painter, he worked in Martinique and discovered Brittany which, though nearer home, was only recently open to railway travel. Here he was fascinated by the unsophisticated and religious nature of the Breton people. He soon yearned for a place that would nourish his interest in so-called primitive cultures and in 1891 he sailed to the Pacific. His intention was to return to his family once his artistic goals were achieved. Survival proved difficult in Tahiti which was not the unspoiled paradise he had anticipated. Though many colonial administrators and missionaries frowned upon Gauguin, the Tahitians, in their turn, found him fascinating.

Gauguin's figure paintings, whether of his own children sleeping or Breton peasants at prayer, often contain mysterious elements that defy analysis. Similarly, in painting the Tahitians, he invites us not only to admire their appearance but also to understand their states of mind. He greatly valued this painting and a few years later claimed it represented a real event that had taken place with his young lover. He embellished the scene with intriguing mystique. Tehura, he said, had stayed up late for his return but alone in the dark was terrified of the possible presence of a night spirit. Unlike conventional nudes in western art, she lies on her front, her firm, rounded buttocks provocatively raised in the centre of the canvas. Subtle contrasts of pink and mauve are carefully placed near the vivid colours that frame her dark skin on pale sheets. Her face turns from the sinister hooded figure behind her. White flashes blaze in the darkness to mirror her startled feelings. 'Never had I seen her so beautiful . . .', Gauguin wrote. He adapted the image in prints and used it as an illustration in his book *Noa Noa* where he described his first years on the island.

He returned to Europe once, for several years, but later sailed even further to the remote Marquesas Islands where he died.

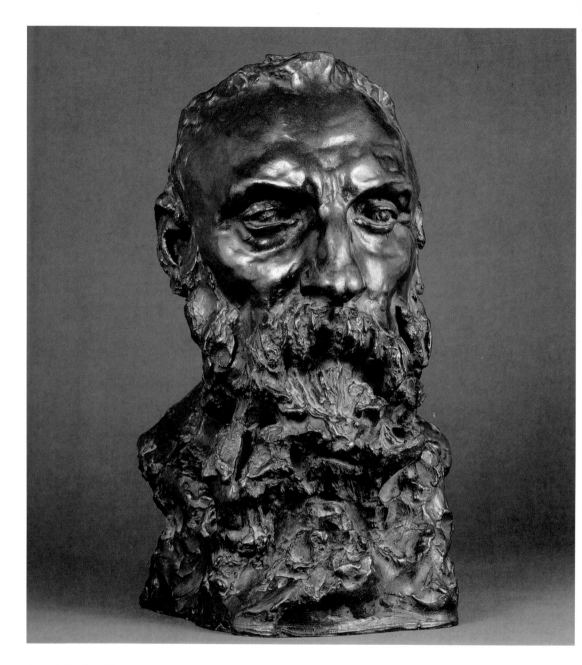

Auguste Rodin 1892
Bronze, 40.7 x 25.7 x 28 cm
Musée Rodin, Paris

CAMILLE CLAUDEL (1864–1943)

Auguste Rodin

As a student of the eminent sculptor Rodin, Camille Claudel may have remained anonymous among others had she not rivalled her master professionally. She was described by the critic Octave Mirbeau as 'a revolt against nature: a woman genius'. Some of her early works share Rodin's interest in posing the human figure in unconventional, even distorted, gestures in order to explore their expressive potential. Her remarkable individuality was fully revealed in tiny pieces of delicately worked materials such as marble and onyx, showing intimate scenes like women chatting or a fireside reverie. She excelled in portraying childhood, youth and old age.

As well as being his student and model, Claudel was also Rodin's lover. She created two similar bronze portrait heads of Rodin that reveal his strong, characterful features. Beneath a ruffled brow, he gazes inquiringly. The surface of his shapely, straight nose, like the rest of his flesh, is smoothly worked and contrasts with her treatment of his hair. The cropped head is well balanced against his coiled beard which flows into a roughly textured base. Rodin's beard covered a badly scarred mouth resulting from an accident years earlier. He greatly admired the bust, using it as his official portrait in exhibitions of his own work.

Rodin was committed to living with Rose Beuret, the mother of his son whom he married in old age. Several private drawings by Claudel came to light in 1982 which show her feelings of anguish and jealousy towards their indissoluble union. Capturing their likenesses and posing them naked in comic situations, Claudel's humour is soured by the irony of her titles and annotations. One is called *Rodin in chains and Rose with a broom*, showing Rodin as a Christ-like figure and Rose resembling a witch. In another, *Le Collage*, she illustrates them stuck together at the buttocks.

From 1905, despite recognition of her work, Claudel began to suffer extreme mental illness. She placed much blame at the feet of Rodin, accusing him of professional jealousy. She was admitted to an asylum and remained incarcerated for the rest of her life.

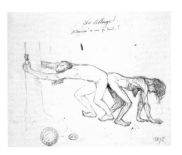

Le Collage 1892
Pen and ink on paper, 21 x 26.2 cm
Musée Rodin, Paris

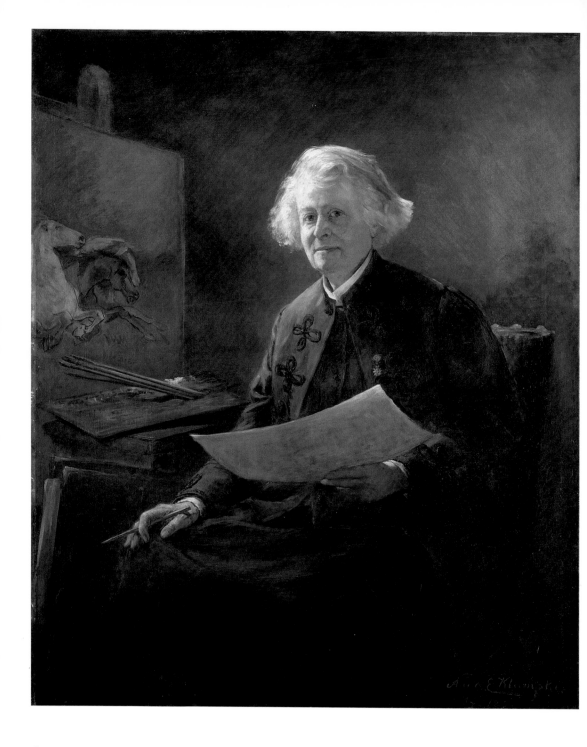

ANNA KLUMPKE (1856–1942)

Rosa Bonheur

Anna Klumpke was born in San Francisco but spent most of her childhood and youth travelling throughout Europe with her family. In her mid-twenties, having studied art in America, she enrolled at the Académie Julian in Paris with a view to becoming a professional painter. She won the grand prize for outstanding student of the year at the Salon of 1884 – great acclaim for a woman at the time. Though she taught in Boston for a few years, she returned to Paris. In 1889 she sought out another woman artist whose work she admired and to whom she had already been indirectly attached – as a child she had owned a Rosa Doll, a toy named after Rosa Bonheur, the celebrated painter of animals.

Rosa herself had exhibited her first work at the Salon. A militant feminist, her hugely popular animal paintings brought her success when many male artists remained struggling. In order to study animal forms she visited horse fairs and slaughterhouses. On these occasions, not wishing to attract too much attention, she obtained permission from the French police to wear men's clothing. She preferred trousers to skirts, smoked cigarettes and owned a lioness, but her unconventional lifestyle did not prevent her from being the first female artist to be made a knight of the Légion d'Honneur.

In order to meet her Anna pretended she was a horse dealer. When she began to paint her portrait, Rosa teased her that she'd made her nose like Cyrano de Bergerac's. 'Over supper she was very merry,' Anna recalled, '. . . even a bit mischievous'. Not long afterwards the two women began to live with each other on Rosa's estate at Fontainebleau.

The lovely portrait shows Rosa at seventy-six, working at an image of two wild horses, her palette and brushes denoting her profession, the medal on her jacket showing her achievement. When she died in 1899 Anna was named as her heir. Anna later founded a prestigious prize in her name and organized the Rosa Bonheur Museum at Fontainebleau Palace. Anna died in San Francisco having written a definitive biography of Rosa as well as her own *Memoirs of an Artist*.

Rosa Bonheur 1898
Oil on canvas, 117.2 x 98.1 cm
Metropolitan Museum of Art, New York

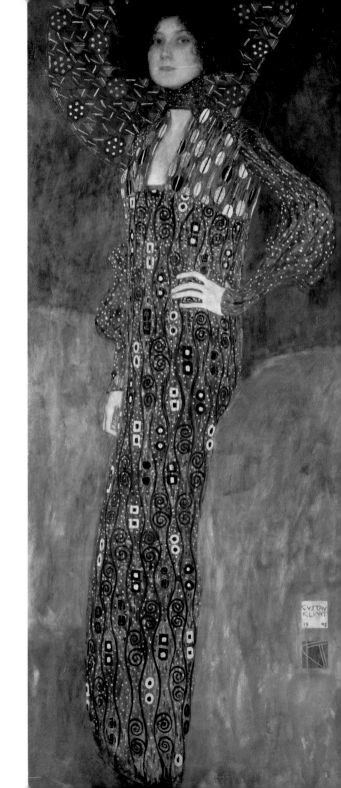

Emilie Flöge 1902
Oil on canvas, 181 x 84 cm
Historisches Museum der Stadt Wien, Vienna

GUSTAV KLIMT (1862–1918)

Emilie Flöge

Was she or was she not his lover? The only certain answer to this question must come from reliable sources. Klimt's fabulous portrait of Emilie Flöge and accounts of the time they spent together have been seen as 'evidence' that they had an intimate relationship. Yet their closeness had much to do with family ties. Emilie was Klimt's sister-in-law and when his brother died, he became a constant figure in the Flöge household, accompanying them on summer holidays to their home on the Attersee, where his interest in landscapes was formed.

After an early career painting public murals, Klimt became a founder member and president of the Vienna Secession, an organization aimed at encouraging unconventional artists. Though the group gained official recognition and was greatly significant in promoting social theories of art and architecture, Klimt's personal preferences led to an outcry of disapproval. His contribution to large-scale allegorical works for Vienna's university were seen as overtly sexual and offensive. The female human figure became a dominant theme in his work and his original use of gold leaf contributed to his portraits' extravagantly decorative surfaces.

Emilie and her sisters, like Klimt, were aware of the changing fashions of their time. They opened a dress shop where restricting corsets and underwear were banished in favour of more sleek comfortable designs. The shop was very successful, its stylish interior encouraging customers' trade – Vienna could compete with Paris when it came to haute couture.

In his portrait of Emilie her pretty face is framed by the gorgeous fabrics that form part of the outfit she models. This concentration on the decorative became typical in Klimt's work (such as in *The Kiss*) where a woman's body takes up the length of the canvas, its inherent erotic qualities becoming swathed in richly patterned clothing.

Klimt was comfortable appearing in public with Emilie, whom he saw almost daily. In his private life he was notoriously promiscuous, fathering many children. But when he suffered a stroke, not long before he died, he called for Emilie to be with him at his bedside.

AUGUSTUS JOHN (1878–1961)

Dorelia McNeill

Augustus John first encountered gypsies during his childhood in Wales. Fascinated, he later decided he wanted to emulate their lifestyle. It was he who asked Dorelia to change her name from Dorothy to something that sounded more exotic. She was probably introduced to him by his sister Gwen John, the artist, while studying at the Westminster School of Art. He later claimed he had caught sight of her in a street and was unable to take his eyes off her for the rest of his life. 'The smell of you is in my nostrils,' he wrote to her, 'and it will never go and I am sick for love of you. What are the great beneficent influences I owe a million thanks to who have brought you in my way. Ardor my little girl, my love, my spouse whose smile opens infinite vistas to me . . .'. Dorelia said that on meeting him she knew at once he was her destiny.

Those who met Dorelia claimed her beauty was extraordinary. Her dress also was unconventional, with floor-length, flowing clothes made of fine fabrics. The portrait of her before a fence may convey aspects of her unusual appearance but more especially it reveals John's romantic view of her. She stands outside, alone in a bleak landscape, yet she is smiling, assured, upright, dominating the hillside. Her dark jacket and skirt are in silhouette, like the strange barrier fence that almost encloses her. Her white blouse is casually yet invitingly revealed. The impact of the stark portrait, with its bold contrasts, was not unlike those of John's French contemporaries, the Fauves ('wild beasts'), who, at this time, were creating startling compositions of great clarity, with bright colours applied in flat patterns.

Though John was married he told his wife, Ida, about his new love. Despite great difficulty they were able to sustain a *ménage à trois* and John painted their domestic life with women working and children playing outside. When Ida died Dorelia became his common law wife. She remained an enigmatic image of bohemian womanhood. In other portraits of her, John's titles frequently refer to her unusual clothes.

Dorelia Standing Before a Fence 1903–4
Oil on canvas, 202 x 122 cm
Tate Gallery, London

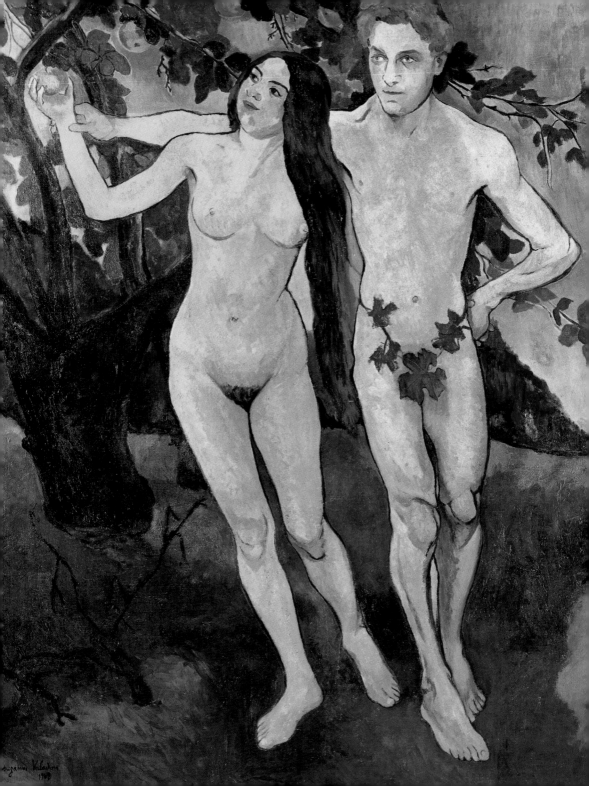

SUZANNE VALADON (1865–1938)

André Utter

Immersed in the dazzling, creative world of Montmartre where she worked as a model, Valadon reached beyond her social milieu to become a serious painter herself. She worked on 'anything that came to hand', she later said, 'including walls and pavements'. Her introduction to Edgar Degas, who examined her work and bought a drawing from her, encouraged her: 'That day I had wings' she explained. Degas became her mentor, arranging her first one-woman show and from then on her artistic career developed.

When her son, the artist Maurice Utrillo, introduced her to one of his friends it marked the beginning of another of her many love affairs. Valadon was married at the time to a stockbroker and living in a comfortable country house. André Utter, twenty-one years her junior, became her primary model, subordinating his own artistic career. The conventional roles of male artist and female model were reversed as Valadon became fascinated by male nudity.

Utter posed as Adam in her painting of Adam and Eve, a celebration of their own relationship (Eve is her self-portrait). In the first version she painted them both entirely nude. However, the honest, realistic representation caused great offence. Before it could be shown at the 1920 Salon des Indépendents Valadon was required to add fig-leaves to cover Utter's genitals.

As the First World War approached, Utter insisted that they should legitimize their relations and become man and wife. Giving up the comfort and security of her first marriage Valadon returned to Montmartre. Here, as before (when she had known Toulouse-Lautrec), she lived with her mother and Utrillo. When the war was over Utter, who had served in the army, took on the management of all their artistic careers and the three often exhibited together. Yet the successes of Valadon and Utrillo were far greater than his own. Heavy drinking contributed to his estrangement from Valadon and he often retreated alone to the medieval chateau they had bought. Though they divorced, their long relationship succeeded in giving each one a unique place in the story of art.

Adam and Eve 1909
Oil on canvas, 162 x 131 cm
Musée National d'Art Moderne,
Centre Pompidou, Paris

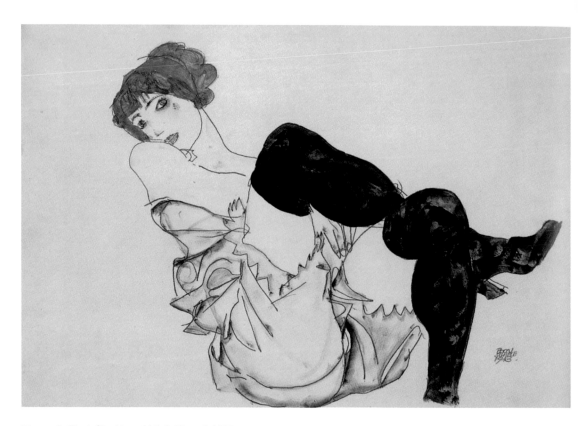

Woman in Black Stockings (Valerie Neuzel) 1913
Gouache, watercolour and pencil on paper, 32.2 x 48 cm
Private collection

EGON SCHIELE (1890–1918)

Valerie (Wally) Neuzel

After studying at the Vienna Academy of Fine Arts, Schiele, along with other artists who were dissatisfied with their training, founded the New Art Group and began to exhibit their work independently. Whilst still in Vienna, Schiele met Gustav Klimt, who became his friend and mentor and who introduced him to one of his models, Valerie Neuzel. She was known to Schiele by a nickname, Wally, and when he became further disillusioned with Vienna, he moved out into the country, taking her with him.

Models in Vienna had been difficult to find once his sister Gerti had given up posing nude for him. In Krumau, his mother's birthplace, Schiele was driven away by suspicious residents who questioned his odd appearance, his behaviour and his choice of local models, including one he posed openly in the garden. Moving on to Neulengbach Schiele invited truant-playing children and other fascinated locals to his studio to sit for him. As models they were inexpensive. One girl's father brought charges of rape and kidnapping against him. In court, over a hundred drawings seized by police were displayed (and one publicly burned). Though he was freed, his local reputation was doomed.

The drawings were considered pornographic. Depicting the human body, Schiele had gone beyond its physical appearance to explore its inherent, occasionally blatant, sexuality. His pictures were expressive through contortion. His fine drawing traced not only the outline of his models' bodies, but often used genitalia as the focal point of the images. Colour washes were then added on specific parts of the drawing.

Aged seventeen when she met Schiele, Wally posed for some of his most striking paintings. These appear to reveal an intimate relationship, yet the poses are too contrived to be anything other than serious studies. Occasionally she is fully dressed, her red hair and bright eyes easily identifiable. Where he poses her (uncomfortably) in black stockings, he transforms her into his own erotic fantasy of a woman. Wally, unsuitable as a long-term partner, continued as Schiele's model until he married one of the well-educated sisters he had asked her to befriend.

Birthday 1915
Oil on cardboard, 81 x 100 cm
Museum of Modern Art, New York

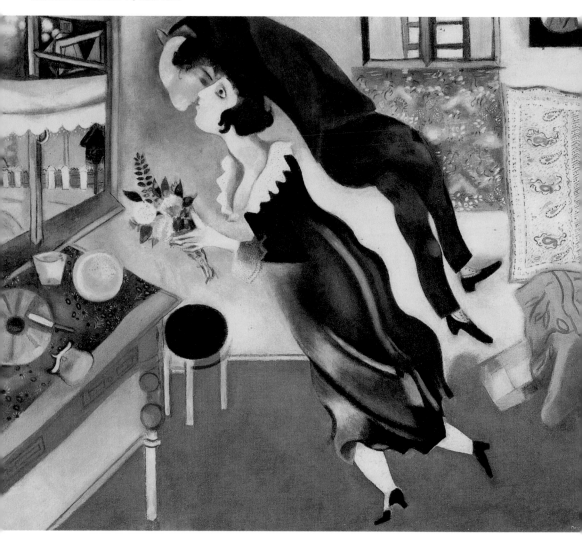

MARC CHAGALL (1887–1985)

Bella Rosenfeld

Chagall was seeing Bella Rosenfeld's friend when they first met. They spoke on a bridge in their Russian hometown, Vitebsk. Later they described this momentous occasion when both felt their future destiny together was fixed. Bella was studying to become an actress and continued her training in Moscow when, before the First World War, Chagall went to Paris to explore the art scene there. Their separation of over two years was hardly sustained through letter writing, but when Chagall returned to Russia during the war they were married in a traditional Jewish ceremony.

He began his celebratory painting of their union on his twenty-eighth birthday, some weeks before the wedding. It represents a single moment when Bella came into the room, yet it conveys the heady rapture not only of their feelings for each other, but of the universal nature of young, joyful love.

'You soared up to the ceiling,' Bella remembered. 'Your head turned down to mine and mine turned up to you . . . Then together we floated up above the room with all its finery, and flew . . .'.

Chagall absorbed the lessons of recent artistic movements such as Cubism. He remained at a distance from Surrealism, yet he created a highly personal world of dream-like narration of the events of his own life.

As exiles in Paris (where Chagall made his Russian name sound French) and in America during the Second World War, he and Bella were able to find in each other a reverence for their treasured past. Motifs and memories of Vitebsk recurred in Chagall's work long after he had left Russia. He claimed that Bella was his muse. 'Everything you say is right,' he said, 'Then guide my hand. Take the paintbrush and, like the leader of an orchestra, carry me off to far and unknown regions.'

As Chagall's wife, Bella took on both maternal and managerial roles in their domestic life. If she suppressed her own career, she furthered his. With their daughter Ida, who did not go to school, they formed a close, cocoon-like family centred upon Chagall's art. When Bella tragically died Ida continued her mother's devoted work.

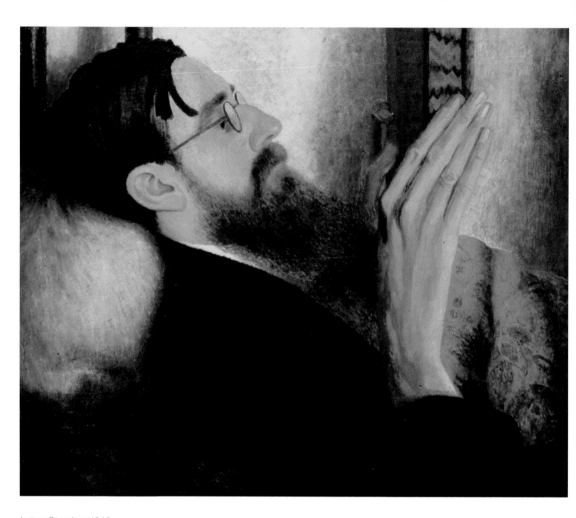

Lytton Strachey 1916
Oil on panel, 50.8 x 60.9 cm
National Portrait Gallery, London

DORA CARRINGTON (1893–1932)

Lytton Strachey

On leaving the liberal Slade School of Art, Carrington dropped her first name, cut off her old-fashioned hair and began her career. She described the failure of her early affair with the artist Mark Gertler: '. . . it is my work that comes between us, but I cannot put that out of my life . . . If I had not my love for painting I should be a different person . . . I at any rate could not work at all if I lived with you every day.'

Carrington painted evocative views of the English landscape where farmsteads nestle beneath steep hillsides conveying a sense of age-old rural calm. She also worked in the decorative arts in the celebrated Omega workshops and created many interior schemes for her friends. As a portrait painter she excelled, capturing the essence of personality in bold close ups with fine colouring. She knew members of the Bloomsbury group and as a visitor to Virginia Woolf's Sussex home she met the writer Lytton Strachey. They are reputed to have attempted sexual relations, but their true closeness came through their intellectual compatability.

'Sometimes with Lytton I have amazing conversations . . . not to do with this world, but about attitudes and states of mind, and the purpose of living. That is what I care for most in him.'

In her portrait she presents him as an intellectual exclusively engaged in reading. Certain features characterize him: his dark lock of hair, his round spectacles and the beard of which he was proud, saying it made him 'look like a French decadent poet – or something equally distinguished'. Above all, his fine, elongated hand betrays his feminine nature. The cool, blue tones capturing a pale, natural light that surround him are brilliantly matched by the deep red patterning of his upright book and the shawl that tucks him up inside his cerebral world.

Carrington lived with Strachey in two of his country homes. When she married they were joined by her husband, to whom Strachey became attracted. The unconventional *ménage à trois* survived, despite many infidelities, but when Strachey died of cancer, Carrington committed suicide, unable to bear his loss.

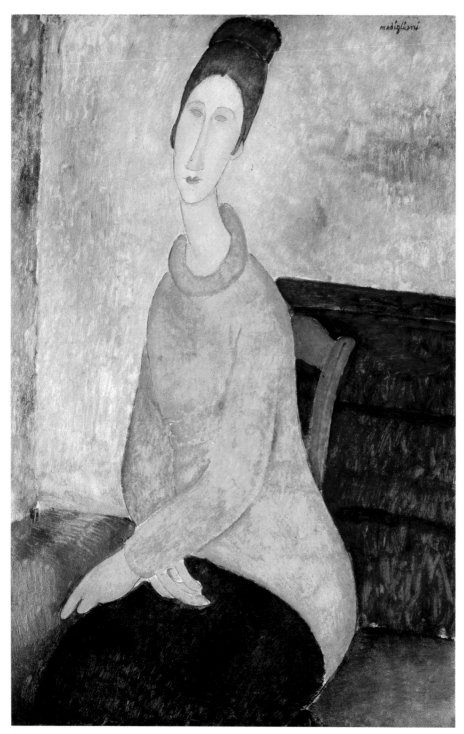

AMEDEO MODIGLIANI (1884–1920)

Jeanne Hébuterne

The Bohemian life – the individual lives of poverty-stricken artists whose genius is unrecognized, the lively Paris of Montmartre and Montparnasse – these potent images remain in our minds with a somewhat mistaken romantic nostalgia. The life was bitterly harsh, even deadly. Jeanne Hébuterne was studying to become an artist when she met the Italian Modigliani. His early training had been in Italy but like many artists before him he was drawn to the French capital to further his career. Though cutting a dapper figure at first, he soon degenerated not only in his dress, but into the abysmal world of heavy drinking and drug abuse.

Jeanne's strictly Roman Catholic family was horrified by her liaison with this young man they saw as debauched, irresponsible and unfortunately Jewish. She turned her back on their disapproval to live with Modigliani, entering a relationship that was remarked upon for its tempestuous public scenes. She appeared in many of his portraits, with titles such as *Jeanne Hébuterne with a necklace*, or 'seated in an armchair', or 'with a large hat'.

Her presence encouraged a new energy in his work.

The portrait 'with yellow sweater' is instantly recognizable as Modigliani's work with its exaggerated, elongated style. Though she was praised for her pale skin and was nicknamed 'Coconut' (from the shape of her head), here Jeanne becomes almost absurdly comic. Her bright blue eyes, without pupils, appear lifeless. The pursed painted lips add to her unnatural appearance. It is difficult to define which of the many exciting experiments and movements in art happening at this time may have encouraged Modigliani to paint in this eccentric way. He was also a sculptor and it is possible he looked to medieval statuary or tribal African art as his motivation for distorting human forms, often lending them vacant expressions and stiff postures.

Although she was expecting their second child, Modigliani's early death drove Jeanne, the very next day, to leap from a window to her own death. Years later her family agreed to have her buried next to him. On her headstone is written 'Devoted companion to the extreme sacrifice'.

Jeanne Hébuterne with yellow sweater 1918
Oil on canvas, 100 x 65 cm
Solomon R. Guggenheim Museum, New York

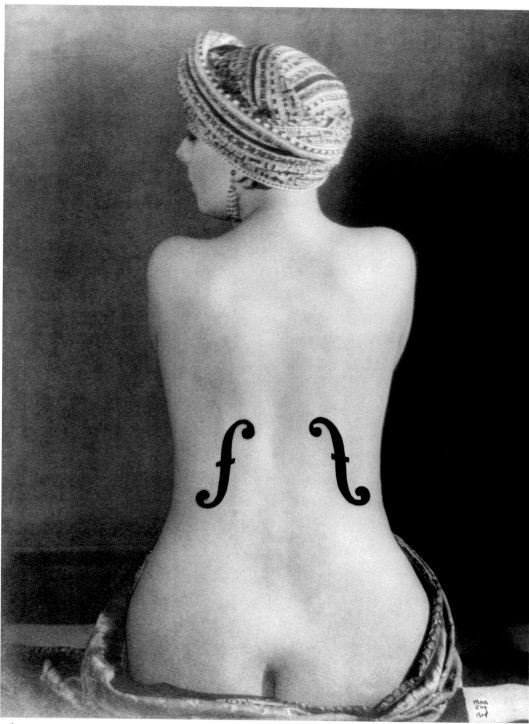

MAN RAY (1870–1943)

Kiki of Montparnasse

Le Violon d'Ingres 1924
Photographic print
Man Ray Trust

In the late nineteenth century the area of Montparnasse, south of the River Seine in Paris, was teeming with established and would-be artists, together with hopeful models who stood at street corners seeking work. Some were already familiar with the studios there. Decades later this was still the quarter where artists came to teach and learn. The young Alice Ernestine Prin, after various menial jobs, came here to earn her own living. Before the age of twenty she was already established as a model. For one artist she appeared at their first session entirely naked beneath her coat. Her popularity grew and she became known to all as 'Kiki'.

Man Ray was an American Jew who, with the rest of his family, had changed his name from Radnitsky. By 1920 he had worked in New York with Marcel Duchamp and become involved in Dada, the anti-art movement. Not long after he arrived in Paris, he approached Kiki, who was sitting at a nearby café table. He asked her to pose for photographs as this was an area of art that

fascinated him. Kiki was suspicious of photography, thinking it too realistic, but finally she agreed. Soon she and Man Ray were in love and living together.

The expression 'violon d'Ingres' refers to the painter who loved to play the violin. It also has the meaning of a hobby, or extra skill. In his famous photograph of Kiki, Man Ray transforms her shapely back into the image of a violin. He did not paint her skin but added the f-holes to a photograph and then made a further photograph of this. The picture may suggest that women can be played with, like a pastime. It certainly turns the traditional idea of the nude upside down and proves the versatility of photography as an artform.

Throughout the 1920s Kiki appeared in Man Ray's experimental films. She posed for paintings as well as many more photos including some daringly close-up erotic views. During the heyday of Montparnasse she was hailed as its queen – portrayed, glorified and loved by many.

Kiki de Montparnasse 1923
Photographic print
Man Ray Trust

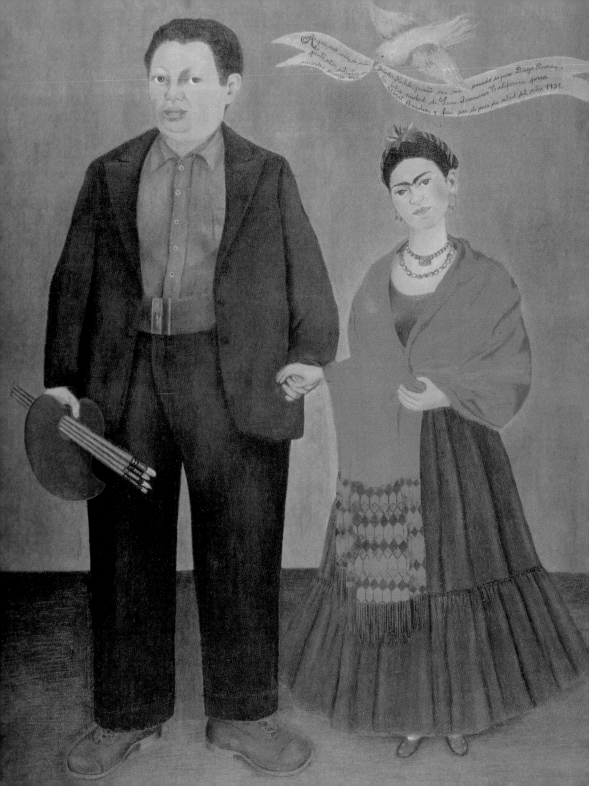

FRIDA KAHLO (1907–54)

Diego Rivera

Throughout her life, following an early road accident, Frida Kahlo suffered extreme physical pain and was periodically forced to work from her bed. Determined to succeed as an artist, she showed her work to Mexico's most famous artist, the mural painter, Diego Rivera. Calling him away from the wall he was working on she explained, 'I have not come to flirt or anything even if you are a woman-chaser. I have come to show you my painting.' He came down his ladder and looked at her work. 'The canvasses revealed an unusual energy of expression, precise delineation of character, and true severity,' he remembered.

Not long afterwards he began to visit Frida's family home on Sundays. Rivera was twenty years older than her, an active member of the Communist party, tall, fat, and, as she described him, had the face of a frog. He was charmed by her bravery, her vitality and her beauty. Their mutual interests and sympathies drew them together and he continued to admire her painting, which he encouraged.

He included her portrait in his mural *Ballad of the Revolution* where she is shown distributing arms to rebellious comrades. Not long after they married she painted them as a couple, like a wedding portrait, in the simple yet bold style of folk art.

In a device used in Mexican colonial painting, a bird flies above them holding a scroll. It bears their names and a dedication to the friend who organized a United States visa for Rivera. Frida, smiling and proud, wears the traditional Mexican clothes that suited her and hid her damaged legs. Rivera is seen as both partner and artist holding her hand on one side and his palette and brushes on the other.

Neither of them remained faithful to the other and though they divorced they later agreed to remarry. Kahlo meanwhile gained true acclaim and not long before she died, was taken in her bed to see a large retrospective exhibition of her work. In his autobiography Rivera wrote, 'Too late now, I realized that the most wonderful part of my life had been my love for Frida.'

Frieda Kahlo and Diego Rivera 1931
Oil on canvas, 100 x 79 cm
Museum of Modern Art, San Francisco

Portrait of Gala with Two Lamb Chops balanced on her shoulder 1933
Oil on canvas, 6.8 x 8.8 cm
Museo Dali, Figueras

SALVADOR DALI (1904–1989)

Gala Dali

The shapely moustache he wore was similar to many in portraits by Velasquez. The style of clothing he preferred was that of the dandyish aesthete. Dali cultivated a unique, theatrical persona, inviting the description 'flamboyant'. In his technically brilliant art he drew on aspects of past periods and contemporary movements to create a unique, eccentric, often disturbing, world. He identified with the Surrealists, controversial artists who explored the dream-like state of the subconscious and treated it with matter-of-fact realism.

Gala was first married to the writer Paul Eluard whom she had met in a sanatorium when both suffered from tuberculosis. She modelled for several Surrealists including Max Ernst, who became her lover. For some years the three lived in a *ménage à trois*. In 1929 she met Dali who was ten years younger than her and they soon formed a relationship. Devoted to Gala, Dali began to sign his works with her name and his, claiming he painted with her blood. On a more practical level, since he was highly disorganized, she acted as his business manager.

In 1934 Dali and Gala were married in a civil ceremony and later, following a papal dispensation, a religious one. When one critic was astounded by this portrait, Dali explained, 'I like chops and I like my wife. I don't see any reason not to paint them together.' Gala appears to be enjoying the sunshine on her face yet she is in a strange, desolate landscape of ruined buildings. The lamb chops are entirely unrelated to the scene which, being made up of such incongruous elements, seems as real as a dream. Eight years later, Dali painted a self-portrait with a rasher of bacon.

In 1982 King Juan Carlos gave Dali the grand title Marquis of Púbol, the village where Dali had bought Gala a castle. Gala died in 1982 and was buried there. After her death a fire broke out at the castle, damaging the building and injuring Dali himself. It was rumoured to be a suicide attempt. Yet the artist had once said: 'Every morning when I awake, the greatest of joys is mine — that of being Salvador Dali.'

Faun Unveiling a Sleeping Woman 1936
Etching and Aquatint, 36.8 x 44.5 cm
Musée Picasso, Paris

PABLO PICASSO (1881–1973)

Marie-Thérèse Walter

Early in his career Picasso drew a touching image of himself deep in thought watching his sleeping lover, Fernande. Over thirty years later he returned to this image, though he is less easily recognizable as a mythological, horned creature. He identified with the faun, as well as the minotaur, two fabulous, strong beasts that exert a magic kind of power over others.

The sleeping naked body is that of his young lover at the time, Marie-Thérèse Walter. She appears in many of Picasso's works, often asleep. Her head, with its widely spaced features, is tilted on one side while her voluptuous, rounded body is coiled in deep repose. Marie-Thérèse was not yet twenty when she met the painter (then in his forties) outside the Parisian department store, Galeries Lafayette. Though he introduced himself, she did not know who he was. He was struck by her fresh looks and the classical qualities of her statuesque physique. She was lively, independent and charming company. Since he was married at the time, he had to keep his affair with her hidden. She later had a daughter, Maïa, to whom Picasso was devoted.

The etching forms one of a large series for the dealer Ambrose Vollard, known collectively as the Vollard Suite and created under contract over ten years. Vollard had opened a gallery in which he sold not only paintings, but also prints: 'My idea was to order engravings from artists who were not professional engravers. What might have been looked upon as a hazardous venture, turned out to be a great artistic success.'

The use of black and white, a distinctive element of engraving, allowed Picasso to explore the dramatic possibilities of this hushed, but potentially disturbing scene, with its brilliant moonlight. He later explained that the faun was studying his mistress, wondering what she was thinking, not quite knowing if 'she loves him because he is a monster'.

Many of Picasso's portraits together form a gallery of his lovers. This frequent theme of artist and model allowed him to explore aspects of his own relationships with these attractive sitters.

Self Portrait with Patricia Preece 1937
Oil on canvas, 61 x 91.2 cm
Fitzwilliam Museum, Cambridge

STANLEY SPENCER (1891–1959)

Patricia Preece

Cookham, the small village on the River Thames, was the birthplace and home of Stanley Spencer. He was so fondly attached to it that 'Cookham' became his nickname. His large works depicting biblical scenes are set here and populated with local village characters he knew. It was to Cookham that Patricia Preece moved to be with her fellow artist and lover, Dorothy Hepworth. Previously they had set up a studio together in Gower Street in London. All three artists had studied at the Slade School of Art.

Spencer was married and the father of two children but was to develop an obsessive and doomed attraction towards Preece: 'There was a sort of passionate intensity and meaning in her loveliness, and perfect shape and appearance', he said at one time. Despite her relationship with Hepworth, which she wanted to disguise, Preece married Spencer after he divorced his first wife, but it was rumoured she refused to consummate the marriage. She became the subject of several nude paintings by Spencer. In two of these he included his own self-portrait. The first literally lays bare the couple's physical and emotional state, presenting them in harsh close-up. From where he is placed, beside the bed, Spencer, bespectacled, looks just above and away from Preece's head. The folds in his pale flesh are as cool as the ruffled sheets on which she awkwardly lies. Preece stares blankly, not at him, but in a kind of fixed reverie. Both have their mouths shut tight and neither person makes any move towards the other. Instead, they become a fleshy still life, their metal-like bodies as keenly observed as the incongruous floral wallpaper and cold bedsteads behind them.

A similar condition is described in the second painting known as *The Leg of Mutton Nude* with its emphasis on starkly exposed genitalia. The musculature of their bodies is compared to a dead joint of meat. Such brutal realism in depicting the nude was used by Francis Bacon and also Lucian Freud who wanted to paint people 'how they happen to be'. Spencer declared that his experience of the erotic was of the same emotional intensity as religious experience. His double portraits expose the poverty of his unhappy marriage which was later dissolved.

ERIC GILL (1882–1940)

Daisy Hawkins

If the reputation of an artist depends on revelations about private behaviour, then the art may either suffer or increase in value. How much of Van Gogh's popularity and saleability is due to a knowledge of his biography? When, in 1989, Fiona MacCarthy published unknown details of Eric Gill's personal diaries he was considered in an entirely new light. Dead for over forty years, his great achievements in sculpture, typeface design and printmaking had been recognized as remarkable. Yet the implications of his intimate writing cast him as an unforgettable, perhaps unforgiveable, pervert.

Over centuries the nude has been portrayed in many different media from marble to mud. In wood engraving, as in drawing, the movement of the artist's hand must be completely assured. If mistakes are made, a drawing can be rubbed out but an engraving will have to be abandoned. Gill's series of Twenty-five Nudes of 1937 shows complete mastery of his craft and also hints at his excellence in stone carving. The engravings also reveal his deep affection for the female body.

The muse in this series was Daisy Hawkins. She came into the Gills' home with her mother who helped with housework. Daisy began posing for Gill and he fell deeply in love with her. He recorded the progress and nature of this love in his diaries, just as he had frequently noted the occasions when he had made love (with his wife, other family members or with mistresses). If he wrote privately about his fascination with the structure and mechanics of genitalia or of experiments with his sister's dog, his depictions of nudity are far from eccentric or distasteful.

In a few elegant lines Daisy is shown in profile, reaching upwards, her head to one side, her hair falling down her back. Tiny delicate marks draw the areola of her nipple, tufts of pubic hair, a few toes of one foot. No more is needed to portray a perfect image of female beauty.

Daisy married another engraver who said of Gill, 'I was bowled over by this idea of craft rather than art'. He had also found in Daisy, the perfect model.

Female Nude Standing 1937
Wood engraving, 23.6 x 14.5 cm
Private collection

Man Ray and Roland Penrose, Los Angeles USA 1946
Photographic print
Lee Miller Archive

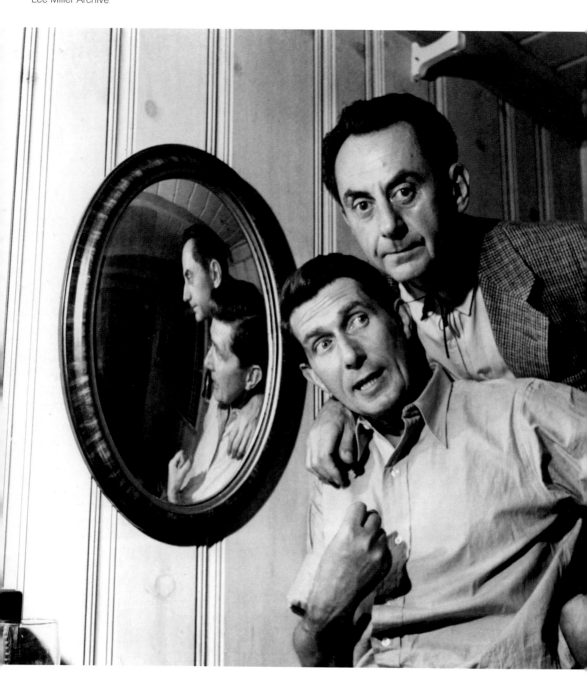

LEE MILLER (1907–77)

Man Ray
Roland Penrose

Lee Miller's beauty exemplified the sophisticated, polished allure of the fashion world. As a model she posed for painters and for many magazines, appearing on the front cover of *Vogue*. Yet her greatest achievement lay in her own work as a photographer. During the Second World War she worked as a photojournalist on major assignments. Her keen eye provided the world with startling images of conflict and its aftermath including the London Blitz, the liberation of Paris and the horror of Nazi concentration camps. Her experiences haunted her in later life.

After the war she took this light-hearted photograph of the two most influential people in her life, her lovers Roland Penrose and Man Ray. The comic pose owes much to the deadpan stare into the camera of Man Ray, on the right. The mirror reflects the men's turned heads, providing an alternative image of both of them in profile. The photo also reveals their friendship.

Miller had met Man Ray, a fellow American, in Paris in 1929. On becoming his model and lover, she posed for much of his experimental photographic work. During their three years together they developed the idea of solarisation where the tonal values of a negative are reversed, producing striking effects. At this time, Miller participated in the Surrealist movement, contributing and developing the unusual techniques she had learned with Man Ray.

Having married an Egyptian businessman, Miller imaginatively explored the potential of the desert for unusual, even surreal themes. Frustrated by life in Cairo, she returned to Paris where she met the artist and collector Penrose at an extravagant party. Soon afterwards they became inseparable, travelling together, visiting friends including Man Ray and Picasso, who famously painted Miller as *L'Arlésienne*. Writing to each other, meeting when and where they could, Miller and Penrose's relationship survived and they married in 1947. In 1966 Penrose was knighted for his services to the visual arts. Their home, Farley Farm in Sussex where they lived with their son, became a place of social pilgrimage for many of their dazzling friends.

ASTRID KIRCHHERR (born 1938)

Stuart Sutcliffe

While attending Liverpool College of Art, the young teenager, John Lennon, encouraged a fellow student, Stuart Sutcliffe, to join his rock'n'roll band, the Quarrymen. By selling a painting, Stu bought himself a guitar and was soon playing bass. Following a few local successes, the group changed their name to The Beatles and set off for their first serious engagement in Germany. Their lively and original performances in the sleazy Reeperbahn district of Hamburg attracted a devoted audience.

A young German photographer, Astrid Kirchherr, watched them play. 'My whole life changed in a couple of minutes,' she later recalled. 'All I wanted was to be with them and to know them.' When she offered them a photoshoot, they were impressed, having previously had only snapshots taken of themselves.

Black clothes, especially leather, and the bleak setting of an empty fairground contribute to her powerful images that suggest the passing of rock'n'roll into the beat era, reflective of the early 1960s. She found the boys 'absolutely, terribly good-looking', yet it was with Stu that she fell in love.

Stu insisted on wearing dark glasses and when it was claimed that Astrid was responsible for the Beatles' distinctive haircuts, she said Stu had already been wearing the style that was common to many German boys. He stayed behind with her when the group returned to England. Later he enrolled at the Hamburg College of Art, studying under Eduardo Paolozzi, the pop artist, who saw him as one of his most gifted and promising students.

Stu and Astrid became engaged and he lived with her family while both planned their future careers. In early 1962, following severe headaches, he collapsed during one of his classes. The condition worsened and he died after a second episode while on the way to hospital. Meeting the other Beatles when they returned to Hamburg, Astrid had to tell them of his death. The film *Backbeat* portrays her involvement with The Beatles and the atmospheric photographs she took of them, important portraits in the history of popular music, have been exhibited across the world.

Stuart Sutcliffe 1961
Photographic print

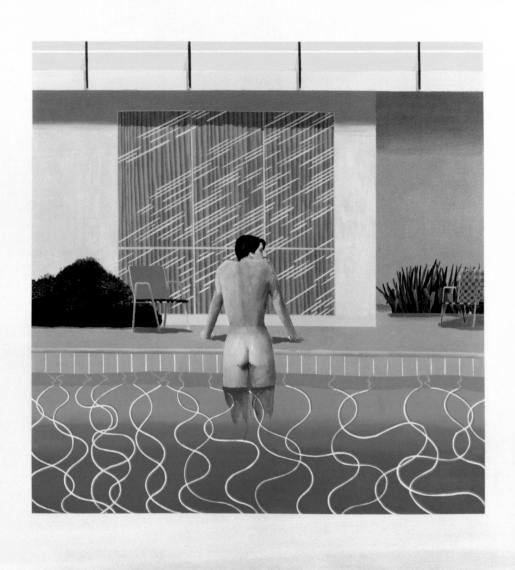

Peter Getting Out of Nick's Pool 1966
Acrylic on canvas, 214 x 214 cm
Walker Art Gallery, Liverpool

DAVID HOCKNEY (born 1937)

Peter Schlesinger

In the early 1960s Hockney settled in California. Here, near glamorous Hollywood, he found light and warmth and a liberal-minded society tolerant of homosexuality. He created brilliant, sun-filled paintings of swimming pools using the acrylic paint that had only recently been commercially available to artists. Although similar to oil paint in its manipulation, it is water based and dries very quickly to a clean, hardened finish. Hockney's celebrated painting *A Bigger Splash* shows the impact a diver makes inside a bright, clear pool, though the diver is not seen. Only the splash remains, against the pristine architecture of the poolside.

Whilst teaching at the University of Los Angeles, Hockney met Peter Schlesinger, a student who became his lover. Here Peter takes his place in a pool where Hockney's friend lived in an apartment block near Sunset Boulevard. At the centre of the painting is Peter's relaxed, pale, upright body. The white house, the tiled terrace, the chairs and green plants are motionless. The rippling surface of the pool is painted in stylized, crisp, wavy lines like the graphic techniques used in advertising. Similarly, the emphatic white painted streaks of sunlight on the window surface are not naturalistic but add to the bright, modern feel of the picture.

The painted scene hardly represents the reality of this particular pool. Its shape is that of a contemporary photograph. For Peter's figure, Hockney copied a Polaroid photo of him leaning naked against a car bonnet. The straight lines were achieved with the use of masking tape and the edges of the canvas were left bare. Hockney was emphasising the nature of the work of art – a work of artifice – and his early paintings reveal his attitudes of exploration, discovery and application that continued throughout his career as he used different media.

'In California you can meet curious and intelligent people,' said Hockney years later, 'but generally they're not the sexy boy of your fantasy as well.' Peter's own ambitions as an artist were frustrated as Hockney's career flourished and the couple separated after five years together.

INDEX

Artists whose lovers appear in the book are in *italic*

ACKNOWLEDGEMENTS

The publishers would like to thank those listed below for permission to reproduce artworks and for supplying photographs. Every care has been taken to trace copyright holders. Any copyright holders we have been unable to reach are invited to contact the publishers so that a full acknowledgement may be given in subsequent editions.

COVER AND 62 © 2010. Photo Austrian Archive / Scala, Florence HALF TITLE AND 66 Musée National d'Art Moderne, Centre Pompidou, Paris, France / Giraudon / Bridgeman Art Library 5 Galleria degli Uffizi, Florence, Italy / Bridgeman Art Library 6 Musée National d'Art Moderne, Centre Pompidou, Paris, France / Giraudon / Bridgeman Art Library © ADAGP, Paris and DACS, London 2010 7 Bridgeman Art Library © Anthony Green 10 © ADAGP, Paris and DACS, London 2010 11 © Tate, London 2010 12 © The Estate of Francis Bacon. All rights reserved. DACS 2010 13 © 2010. White Images / Scala, Florence 14 © 2010. Photo Scala, Florence 18 © 2010. Photo Scala, Florence – coutesy of the the Ministero Beni e Att. Culturali 20 © 2010. Photo Scala, Florence / BPK, Bildagentur fuer Kunst, Kultur und Geschichte, Berlin 24 © National Gallery of Scotland, Edinburgh / Bridgeman Art Gallery 30 © 2010. Photo Art Media/ Heritage Images / Scala, Florence 37 © Tate, London 2010 44 © 2010. White Images / Scala, Florence 48 Bequest from the Collection of Maurice Wertheim, Class of 1906 50 AND BACK COVER © Samuel Courtauld Trust, The Courtauld Gallery, London, UK / Bridgeman Art Library 54 Private Collection / Giraudon / Bridgeman Art Library © ADAGP, Paris and DACS, London 2010 58, 59 © ADAGP, Paris and DACS, London 2010 60 © 2010. Metropolitan Museum of Art, Gift of the artist in memory of Rosa Bonheur / Art Resource / Scala, Florence 64 Private Collection / Bridgeman Art Library © The Estate of Augustus John. All rights reserved 2010 70 Museum of Modern Art, New York, Acquired through the Lillie P. Bliss Bequest © ADAGP, Paris and DACS, London 2010 72 Private Collection / Bridgeman Art Library 76 © Man Ray Trust / ADAGP, Paris and DACS, London 2010 / Scala, Florence 77 © Man Ray Trust / ADAGP, Paris and DACS, London 2010 78 © 2010 Banco de México Diego Rivera Frida Kahlo Museums Trust, Mexico, D.F. / DACS, London 80 © Salvador Dali, Fundació Gala-Salvador Dalí, DACS, London 2010 82 © Succession Picasso / DACS 2010 84 © The Estate of Stanley Spencer 2010. All rights reserved. DACS, London. Fitzwilliam Museum, University of Cambridge, UK / Bridgeman Art Library 86 © Estate of Eric Gill 88 © Lee Miller Archives, England 2010. All rights reserved 90 Getty Images. Photo by Astrid Kirchherr – K & K / Redferns 92 © David Hockney

JULIET HESLEWOOD studied History of Art at London University and later gained an MA in English Literature at Toulouse. For over twenty-five years she lived in France where she devised and led study tours on art and architecture as well as continuing her writing career. Her books include *Mother: Portraits of 40 Great Artists*, *Introducing Picasso* and *The History of Western Painting* for young people which was translated into twelve languages. She also wrote its companion on sculpture. Juliet now lives in Oxfordshire where she continues to write and is a freelance lecturer in History of Art.

The Author's Husband After multifarious experiences of love, at the age of fifty-six I married my most importunate suitor, Donald, who admires the correct use of unusual words. He gave me my digital camera with which I snap many memorable shared occasions.

Frances Lincoln Limited
4 Torriano Mews
Torriano Avenue
London NW5 2RZ
www.franceslincoln.com

A catalogue record for this book is available from the British Library.

978-0-7112-3108-5

Printed and bound in China

1 2 3 4 5 6 7 8 9